The Londonderry & Lough Swilly Railway

A Visitor's Guide

to the old railway and all the bits that can still be seen

by

Dave Bell and Steve Flanders

Illustrations by Blanche Pay and John Baird

COUNTY DONEGAL RAILWAY RESTORATION SOCIETY

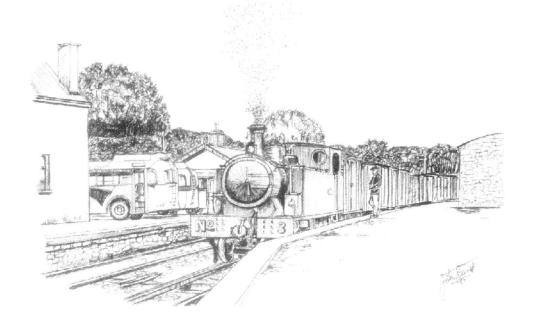

A few words before we dive in ...

Maps

The Ordnance Survey of Ireland publishes the excellent Discovery Series of 1:50,000 maps which, most importantly, show the routes of the old railways. We would recommend that you buy the relevant ones covering north and east Donegal: nos. 1, 2, 3, 6 and 7. To completely cover the whole of County Donegal you'll also need to buy maps 10, 11, 12 and 16, which show the south part of the County. This may seem a substantial investment but it will certainly help you find your way about and you're bound to discover lots of other places to visit.

Map References

Amongst the text you'll find six-figure map references which pinpoint the exact location of the sites we refer to.

It's easy to read a map reference.

The six figures are divided into two groups. The first three numbers are the "Eastings" and the second three-number set are the "Northings". First, across the top of the map, find the blue *vertical* line labelled with the first two numbers of the Eastings and then estimate across the tenths (the third number of the Eastings) towards the next line. Now, down the side of the map, look for the "Northings" – the *horizontal* blue lines. Find the Northing line with the first two numbers of the Northings' reference and estimate the tenths. Trace the two co-ordinates across the map, where they cross is the point referred to.

For example:

Let's find the crossroads at Gweedore on OS map 1.

It's map reference is 853225. The Eastings are 853. Find the number, "85", along the top of the map and follow the *vertical* blue line down, you'll find the numbers repeated several times along the line down the map to help you. When your finger reaches Gweedore estimate the third number of the Eastings as three tenths of the box to the *right* of the 85 line. Now repeat the same process with the Northings: 225. The numbers are on either side of the map. Find the 22 and follow the line across the map. When you reach Gweedore, move your finger *up* by five-tenths of the box. The two co-ordinates co-incide at Gweedore crossroads. That's it! You can now read a map reference!

Place-name spellings

The names of places in Ireland almost entirely derive from the original Irish names given to them by the local people. These names were rarely written down and then usually as transliterations in English. Clearly, this has led to some considerable variation in the correct spelling and so we have adopted the following nomenclature.

Railway stations and sites are labelled with the names and spellings given to them by the railway company, place names are spelt as in the OS maps. For example, Kincaslough village (*Cionn Caslach* in Irish) and Kincasslagh [Road] Station.

Place-name spellings appearing in quotations are given as they were originally published.

"Over" and "under" bridges

These are referred to throughout the text. An overbridge is where a road went *over* the railway, an underbridge where a road passed *under* the railway.

Crossings

There were two main types: *crossing gates* with their attendant houses where the railway crossed public roads, the gates were normally kept *closed* against the railway and opened only for the passing of trains; and *gated accommodation crossings* where the railway was crossed by private accessways, for example into a farmer's field, the gates were normally kept *open* for the railway.

Please remember!

It's been many years since the Lough Swilly Railway closed and the fine buildings and well-constructed civil engineering works are now all in private hands.

All of the sites (and sights!) can be enjoyed from public roads and paths.

Please do not trespass.

Please do not block field gates, farm entrances or other accessways.

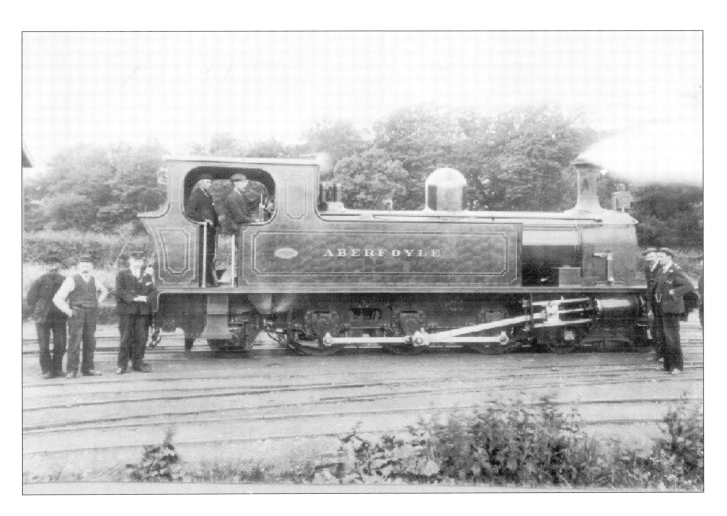

The Londonderry and Lough Swilly Railway

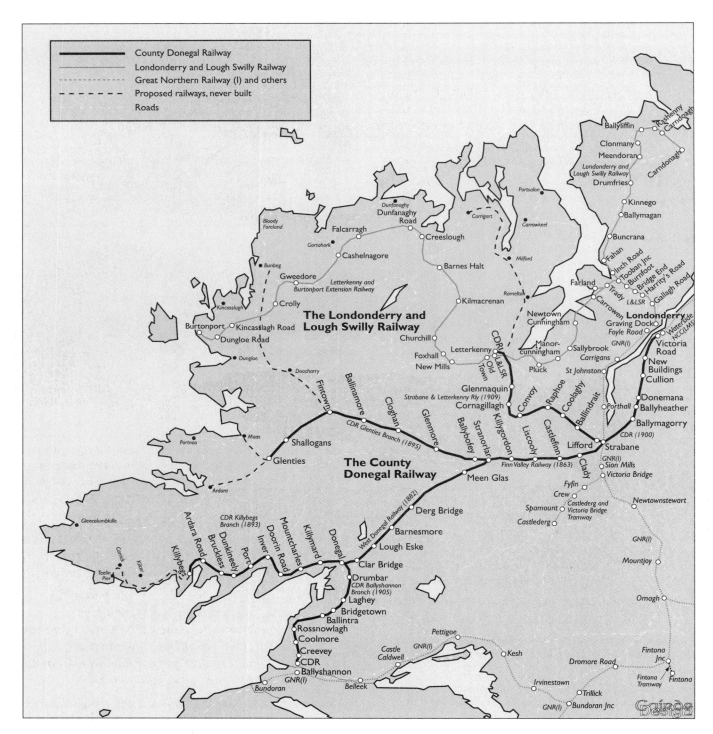

The Railways of Donegal

Our map shows the hundreds of miles of narrow-gauge railway lines that once traversed Donegal during the heyday of the steam train. Apart from the CDR and L&LSR, the Great Northern Railway of Ireland had several important connections for the County, including its lengthy branch to Bundoran.

Previous page

Aberfoyle on the day of her arrival, new, at Letterkenny in July 1904. She stands with the station staff and crew proudly displaying her for the camera. The third figure from the left is Robert Bell, the author's grandfather and Station Master at Letterkenny. The others are Messrs G Starrett, O'Donnell, McGilloway, Baird, Strutt, Mills and George. It's believed that the station buildings are about 100 yards away to the left. This photo was discovered in the family attic a few years ago and is, of course, the author's most treasured possession and reminder of times past.

To set the scene

The catchment area of the railway companies that were to eventually become the Londonderry and Lough Swilly Railway was all that area of County Donegal extending from Derry westwards to Letterkenny and beyond, and northwards to either side of Lough Swilly itself.

This vast region comprises large stretches of good farmland bounded by steep hills and mountains on peninsulas deeply cut by sea loughs. West of Letterkenny the north-east to south-west grain of the granite mountains are suitable only for sheep and, on their seawards fringe, for fishing and subsistence cultivation.

The improvement of communication between Lough Foyle and Lough Swilly was being considered in the early decades of the nineteenth century as an important step forward for commerce and it had been decided to reclaim land and build a canal connecting the two loughs. This was a period when coastal shipping was often quicker than any overland transport system and the sea loughs of Ireland were important arteries for trade of all types. Indeed, many of the small towns along the shores of Lough Swilly had much better contact with Glasgow, by boat, than with Dublin, by cart.

The canal project was only part of the overall improvement considered. A large area of low-lying land opposite Inch Island was regularly inundated by the tides and it was the main concern of the development project to build lengthy embankments to reclaim many hundreds of acres for farming.

Accordingly, between 1838 and 1850 four massive embankments were constructed. These were the Trady Embankment linking Burnfoot to Trady Island; the Blanket Nook Embankment just north of Newtowncunningham; and the two stretching across the lough to Inch Island – from Quigley's Point and

Below: Loco no. 3 prepares to leave Tooban Junction with a goods train bound for Buncrana on the 20th April, 1953. The only buildings at the junction are the signal box and goods store. *H C Casserley*

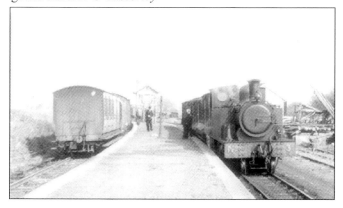

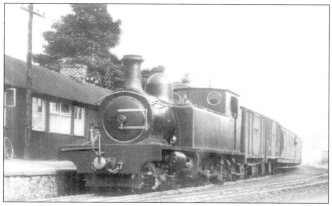

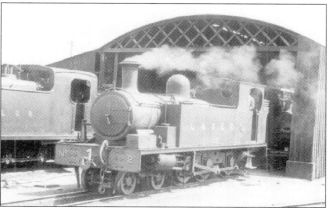

Top: Loco no. 15 at Pennyburn Station on the 6th August, 1930. She is hauling a mixed train and is facing towards Graving Dock Station. *H C Casserley* *Above:* Letterkenny and Burtonport Extension Railway loco no. 2 at Pennyburn shed on the 24th June, 1937. *H C Casserley*

from just east of Farland Point respectively. Altogether they enclosed almost 3,000 acres of reclaimed land.

The canal was to have been an integral part of this scheme but a combination of cost, engineering difficulties associated with the varying tidal ranges of the two loughs, and the rapid growth of railways elsewhere led the businessmen to move away from the scheme. Instead, a railway was promoted.

A company was duly incorporated and a line planned to run from the quayside at Derry along the Skeoge River valley as far as Burnfoot and then along the top of the Trady Embankment to Farland Point where there would be steamer connections throughout the lough and beyond.

The railway was planned, and indeed built, to the Irish standard gauge of 5ft 3ins.

While it was under construction it was decided to make a junction just west of Burnfoot and to then turn northwards along the coast to Buncrana.

The line to Farland Point opened on the very last day of 1863 and that to Buncrana sometime towards the end of the following year. Unfortunately, the service to Farland Point was very little used, steamer timings not

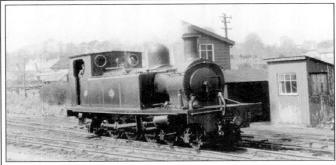

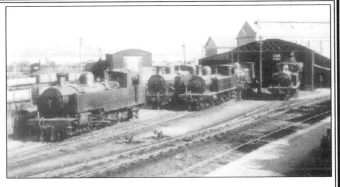

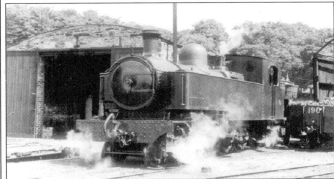

LOCOMOTIVES OF THE LONDONDERRY AND LOUGH SWILLY RAILWAY

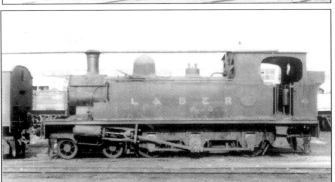

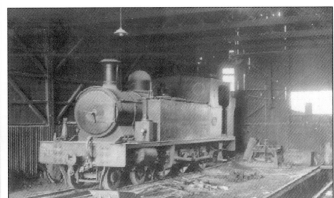

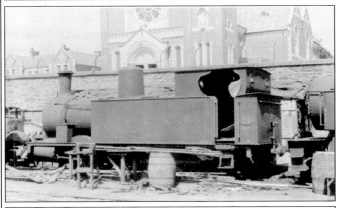

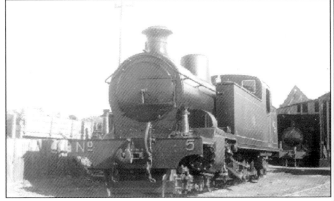

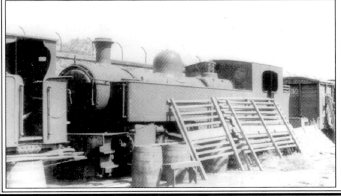

Left, top to bottom: **1** – 4-6-2 loco no. 15 at Letterkenny on the 20th April, 1953. **2** – No. 14, also at Letterkenny, 24th June, 1937. **3** – L&BER no. 4 at Pennyburn, 20th April, 1953. **4** – 0-6-0 no. 17 on scrap line at Derry, 24th June, 1937. **5** – Another awaiting the cutter's torch: no. 13 also photographed on the 24th June, 1937. *Above, top to bottom:* **1** – A line up of Lough Swilly steam at Pennyburn loco shed on the 6th May, 1938. Locos, 14, 5, 16, 12 and 8. **2** – 4-60 loco no. 4 inside Derry shed on the 19th April, 1948. **3** – A good view of the last no. 5, Pennyburn, 19th May, 1950, a few short years before closure. All photographs: *H C Casserley*

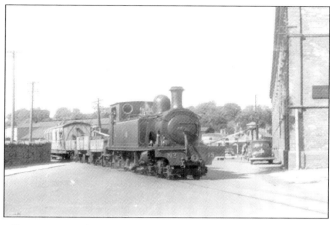

Above: No. 15 hauls her short goods train with passenger brake van across the skewed crossing between Pennyburn and Graving Dock Stations on the 19th May, 1950.
H C Casserley

being under the railway company's control, but that to Buncrana flourished.

Accordingly, by 1866, after only three years' service, the Farland branch was abandoned and the Londonderry and Lough Swilly Railway concentrated all its services on the line to Buncrana.

But, in Letterkenny, things were beginning to move. Several projects had been mooted to bring this important town into the railway network and the two foremost schemes were for a branch leaving the Londonderry and Enniskillen Railway's line running alongside the River Foyle at Cuttymanhill following a westward route, or a line from the L&LSR's abandoned track at Farland Point south-westwards via Manorcunningham and Pluck.

In the event, it was the latter route that was chosen and the Letterkenny Railway Company's 3ft narrow-gauge line from Tooban Junction to Letterkenny was opened

Below:
Another view of no. 5, this time shunting freight vans at the goods store in Letterkenny in the last few months of the railway's operation. 20th April, 1953.
H C Casserley

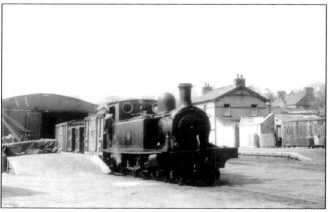

in 1883. The L&LSR remained with the standard gauge of 5 ft 3 ins for a further two years so that a change of trains – and gauges – was always necessary at The Junction.

But in 1885 the logical decision was taken and the L&LSR regauged to 3ft. The key figures in the railway's development at this time were Messrs McCrea and McFarland who, together, took the business in hand and, through strict economy measures and dilligent investment, advanced the company's standing and resources.

The line to Letterkenny was nominally independent as the Letterkenny Railway Co., although it was worked throughout by the L&LSR and eventually absorbed by it. Meanwhile, the 5ft 3ins gauge stock was auctioned off, the track narrowed and the railway entirely re-equipped with 3ft gauge motive power, passenger and freight vehicles. This meant that, by 1885, the L&LSR was a unified narrow-gauge network some 31 miles long and consisting of two lines linking important towns to the city of Derry.

The last decade or so of the last century saw many plans for further expansion but it wasn't until the government offered funding for the building of railways in the so-called "congested" areas that any new lines were built.

The term "congested" was always a bit of a misnomer. In the government's eyes there were too many people living in the more remote counties of Ireland – the land being inadequate to support them, it was claimed. However, in 1841 some 296,000 people lived in County Donegal – about 500 per habitable square mile, but some ten years later this figure had fallen by 41,000 – a catastrophic decline when you offset deaths against births.

Of course, the great famine and resultant mass emigration was to blame. Ireland's agricultural industry was very similar to that of developing countries today: the best land went to growing cash crops for export on the foreign-owned estates while the working people had to make do with their small plots on the fringes, the poorest soil.

The big estates produced beef cattle, milk, eggs, poultry, lamb, mutton and many other high-protein foodstuffs but these were destined for the British market where Irish, produced goods were invariably sold at the lowest prices despite good quality in comparison with English-produced varieties. In fact the cheap food from Ireland kept the British working class fed – and that meant that the Industrial Revolution there was partly fuelled on Irish-produced foodstuffs.

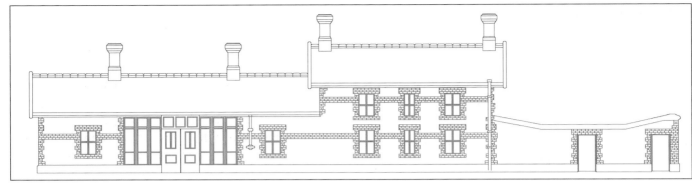

A diagrammatic representation of the platform elevation of Carndonagh Station. The station buildings of the Carn line, and that of Buncrana, were all built to a distinctive pattern utilising decorative glazed bricks to add character.

The Irish working people had to make do with the cheapest possible crops and so, inevitably, became reliant on a small selection of vegetables and the poorest remnants of meat. So when infection hit the potato in 1845-7 although it affected the big estates to some extant (principally in animal foodstuffs), to the peasantry it was a death knell. There was plenty of food to go round and, indeed, government stores of grain in the worst-affected areas in the west of Ireland but the British government's policy of the time was dominated by what we would now call "market forces" and the food when to the highest bidder. With the average family income in Donegal being about £20 a year the people were in an impossible position.

Thousands starved. Thousands emigrated. The country's population of eight million plummeted. It has never recovered. It was a national catastrophe. Lives sacrificed on the altar of commercial enterprise.

By the latter part of the nineteenth century, thirty or forty years after the worst ravages of the famine, the government stepped in to alleviate the situation to some degree. Better land was bought from the big estates and was added to the smallholdings of the peasantry. Fishing was promoted as another suitable rural activity and there were certainly ready markets for the sea's produce.

So it was that government funding became available for the development of the fishing industry and the improvement of communications – principally railways – between the fishing ports and the main towns and cities.

In the south of the county this resulted in grant aid for the CDR line to Killybegs and to Glenties, and later to Ballyshannon. For the Lough Swilly it meant the construction of two lines: the previously-considered extension to Carndonagh from Buncrana, and the long winding line to far-off Burtonport.

The Carn line was built entirely with grant aid, the L&LSR supplying the rolling stock for the trains.

Below:
One of the two most massive tank engines to ever operate on any Irish narrow gauge line. No. 5, an enormous 4-8-4 locomotive, was built in 1912 by Hudswell Clarke, carried a coal capacity of 2.5 tonnes and had a total weight of some 53.75 tonnes. No. 5 covered almost 70,000 miles in service and performed the last rites by hauling the wrecking train when the railway was closed. She was scrapped in 1954.
H C Casserley

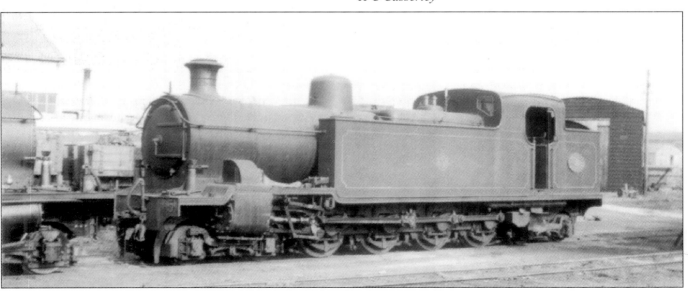

Crossing the road just north of Buncrana station it headed for the only significant pass through the mountains, north-eastwards to Drumfree, and then veered north-west to Clonmany and Ballyliffin.

It then followed the coast, turning east and then south-east before terminating at Carndonagh.

The Burtonport line was also built with grant aid and its sole objective was to link the fishing port with the rest of Ireland's railway network. Consequently its route ran first west then north of Letterkenny as far as Creeslough when it then swung westwards again towards Errigal and threaded a path through the mountains and moorlands to Gweedore and Burtonport. Despite traversing over 50 miles of the county this line managed to avoid most of the coastal settlements – at best they were served by stations two or three miles away – and therefore from the start was reliant on whatever freight traffic it could win.

The turn of the century and the years before the First World War saw the Lough Swilly at its most developed with over 100 miles of narrow-gauge line, a developing fleet of locomotives and new coaching and goods stock. Steamers operated up and down the lough and connected with trains at Fahan pier; the services to Rathmullen, Ramelton and Portsalon being the most popular. The steamer company, although owned by McRea and McFarland, was never part of the railway company's operations.

But, even as the railway grew and consolidated, the times conspired against it. Successive examinations and enquiries raised doubts about safety and correct working practice while income never generated sufficient profit to justify any reasonable level of dividend for the shareholders.

Ireland's struggle for independence after the First World War again left its mark on the Lough Swilly. Trains were often used to transport British troops and the local staff frequently refused to operate them. The railway itself was attacked and damaged so as to prevent troop trains from running and on at least one occasion a mail train with plain-clothes British agents on board was attacked and a running gun fight ensued.

After the partition of the country the war for independence continued as a civil war between those who supported the emasculated 26-county Free State and those who continued to fight for the independence of the whole of Ireland from British rule. Throughout the L&LSR's area this war was hard fought and many incidents involved the railway until hostilities largely ended in 1925.

A further complication caused by Partition was the introduction of customs checks on every train passing along the line to Derry. Bridge End and Tooban were the site of the Free State checks while Gallagh Road was the home of the Northern Ireland customs officials.

The 1920s and '30s were the crunch period for the Swilly. Further south the County Donegal was already successfully utilising first petrol and then diesel-powered railcars but this option was not taken up by

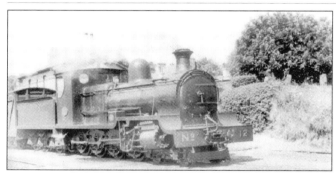

Above: No. 12 at Letterkenny, 1937. H C Casserley *Below:* Ballymagan Station, on the Carndonagh line, another fine example of the use of decorative brickwork by the builders.

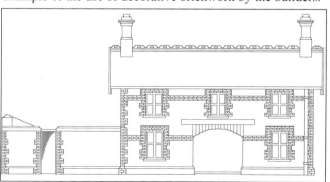

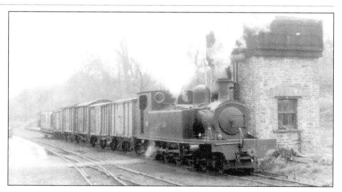

Above: Loco 15 pauses with a freight train at the water tower at Newtown on the 20th April, 1953. *Below:* No 12 also takes water although this is some 16 years earlier and the location is Creeslough. *Both H C Casserley*

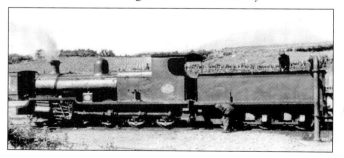

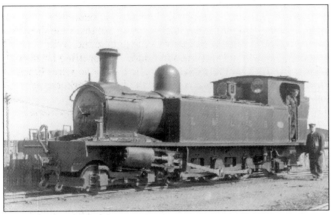

Above left: Letterkenny, the up platform. No. 15 pauses with the 2.15pm mixed train to Derry. Note the CDR vans. These would have ben transferred to L&LSR metals via the connecting line just east of the station. *H C Casserley*
Above: Dave Bell's father, Cecil Bell, stands outside the L&LSR parcels office and stationmaster's house at Letterkenny, where he was born. A CIE road bus stands on the platform where passengers once awaited the trains.
Left: Loco no 8, one of the 4-8-2 tank locomotives is seen here at Pennyburn yard, Derry sometime over the Whitsun weekend of 1937. Although obviously well used she looks well maintained. The impressive size of many of the Lough Swilly engines an be appreciated here. *H C Casserley*

the L&LSR directors. Instead, they viewed the general decline in railway revenue as an indicator that the company's future lay with road transport and began the first of many purchases of suitable road vehicles.

1935 saw the writing on the wall with the Carn line north of Buncrana being closed after only 34 years of service. Retrenchment of rail services continued while the road transport fleet rapidly expanded and, it must be admitted, the financial health of the company improved. Dividends of 5% now became possible and these were to grow to 7% as further railway routes were replaced by bus services.

The Burtonport line was due to go in 1940 and was already being ripped up when there was a stay of execution caused by a national fuel shortage. Ironically, the Second World War gave the line, at least as far as Gweedore, another seven years of life as a freight line carrying turf and anything else the railway could attract.

But it was only to be a short respite. 1947 found rail passenger services only running from Derry to Letterkenny and freight only to Buncrana. The buses

had won! And small wonder, as at least they actually went into the little towns and villages rather than giving them a passing nod from a hillside several miles away.

In 1953 the company went over entirely to road transport, the last railway routes were closed and the track lifted.

Since then the company has continued as the major passenger and freight haulier for the north of the county and its red and white buses are a familiar sight when driving about. Many of the stations still stand, often as private houses or bars, some derelict, some demolished. Viaducts and bridges span rivers but no trains now pass, stone pillars and abutments stand as mute testimony to the days when the narrow-gauge trains of the Londonderry and Lough Swilly Railway steamed their way through the moorlands and glens of County Donegal.

So, with a spirit of adventure and discovery, let's undertake an exploration of what *does* remain of the old railway as we seek to recapture the spirit and flavour of times gone by.

By Goods to Gweedore

by K Longbottom

Quoted from the November/December 1949
issue of *Railway Magazine*

One day in March, 1946, when two daily goods trains in each direction were still running between Letterkenny and Gweedore, we were allowed to travel by the afternoon service, and, armed with a camera, duly presented ourselves at Graving Dock Station, Londonderry, to obtain the much-coveted pass and join the 10.45 am mixed train to Letterkenny. Our train was backed in ceremoniously by No, 6, a 4-8-4 tank engine, very large for the gauge and weighing 52 tons, after several of us had assisted the station staff to push clear a van which had been left in possession of No. 1 platform by some previous shunting operations. It consisted of a tank wagon, some assorted vans – one carried on bogies – a bogie open wagon and two trucks of turf, completed by a bogie brake coach (definitely third class!) and pipe-fitted throughout.

With a hoot on her chime whistle, No. 6 set her 3 ft. 9 in. drivers turning and we were off round the curve through Pennyburn works. Bridge End is the border station and the scene of many a sad parting between enterprising shoppers and their purchases – for it is a stronghold of the Customs – and half an hour is allowed in the timetable for examination and shunting.

At Tooban Junction, the Crewe of the system, trains were piling up on the signalman and we came to a halt for the staff. A change of train was necessary at Letterkenny, for here the great adventure began and our goods train was loading up, with No. 2, a very "Caledonian" (even to her hooter) 4-6-0 tank looking spick and span in fresh black paint, all ready to back on. Her driver, a jolly Irishman called "Paddy" Clifford, looked out of his cab and appeared rather amazed to find he had two valuable passengers in his charge.

With just over 70 tons tare behind her, including the inevitable bogie compo. for the guard and ourselves, No. 2 proudly took the afternoon "Green Arrow" freight out for the Far West. There was no starting "rugg" because of the auto-couplers of the stock, as we looked out of our compartment, which was akin somewhat to the groom's quarters in a horse box, and the riding was extraordinarily smooth for a mineral line, some of the track having been relaid with 60 lb. rails in place of the old 50 lb. just before passenger traffic was abandoned. Soon we were climbing through New Mills and Foxhall, both of which are closed entirely, their buildings doing their bit to ease the housing problem, and Kilmacrenan was reached at four o'clock. It was here that my companion took to the footplate. From this point onwards the full scenic glory of the route developed as the line makes its way through the famous Barnes Gap with many narrow rock cuttings and sheer precipices.

We left the Gap to cross the wide Glen Lough by Owencarrow Viaduct, a structure ill-famed for the disaster which overtook a westbound train on January 30, 1925. There used to be a joke about the train which was always late "when the wind was against her," but on this occasion it rose to over 100 m.p.h. and did far more, overturning some of the carriages and killing four people; the breach in the parapet is still visible. Anemometers were installed at Dunfanaghy Road and when the wind velocity reaches 60 m.p.h. open wagons are not included in the train; a speed of 80 m.p.h. causes a complete suspension of all traffic.

Creeslough, about the mid-point of the Extension, is the principal stop and here water is taken. We took advantage of the time to nip up to the village for "restoratives" but, lest we were marooned in this lonely spot, took the driver along with us!

It was now my turn for the footplate and I looked forward to a *tour de force* up to Falcarragh. Fuel for both directions is carried and conditions are apt to be a bit cramped at times, but I found a station behind the driver where I could make myself useful also with the hand brake should the vacuum prove insufficient to hold the train! We set off with the regulator set at second port and cut-off about 75 per cent. (third notch) which was increased as the gradient stiffened, after the preliminary run down into Dunfanaghy Road. This formidable bank is three-and-a-half miles long at an average of 1 in 50, and engines of No. 2's class are allowed to take only 100 tons over it. Here the elements can make life distinctly unpleasant for the engine crew, but this time they were kind to us and the ascent was made in grand style, steam never falling below 130 lb., under the beetling shadow of Muckish, a 2,187 ft. mountain. The telephone wires have been removed from Falcarragh and the line is worked now by either "bush telegraph" or, more probably, on the understanding that one engine only is allowed beyond here.

Glorious glimpses of Tory Island on our right and the Derryveagh Mountains on the fireman's side were ours as we proceeded towards Slieve Errigal (2,466 ft.), but Driver Clifford had more to do than admire the view! His chief trouble was stray sheep, and he scared most of them off with the draincocks and whistle. Usually this only had the effect of herding them into the three-foot just a bare length ahead of the engine and quite spoilt what might have been a grand descent into Gweedore now only half a mile away. One was "bagged" but gave the rest of the train a wide berth and appeared only somewhat shaken. At Gweedore the now familiar procedure of pulling up well short of the station, uncoupling the locomotive and using her for advance shunting duties, was adopted. When these are completed, the screw-brake in the van is eased and the train runs down into the platform; as the guard said: "It's useful having all your stations in the dip!"

Beyond Gweedore a rather forlorn looking iron bridge crosses the River Clady, and the route to Burtonport can be seen clearly, shorn of its rails and sleepers, streaking across the Rosses in search of the sea. The abandonment of the original terminus has deprived the trainmen of the use of a turntable and the return has to be made with the chimney still pointing west. What conditions must be like running backwards in falling snow with No. 12, the company's only tender engine, is best left to imagination. However, Paddy Clifford, who has served with the company since 1910, considered running the Extension a grand job.

Our last glimpse of the train was during the bumpy journey back on the following day by bus – what a contrast to the smoothness of the railway – for there was No. 2 again bringing in the afternoon freight, a wisp of steam some four miles away marking her progress across the moors, backed by the grandeur of the mountains … (abridged)

From the Foyle to the Swilly

Derry to Bridge End

Our tours of the Lough Swilly Railway don't cover this section as there is so little left to see. But if you would like to travel the whole route of the old railway then drive direct to Derry and begin from the quayside near the old dual-deck bridge.

And before you set off, why not take the opportunity to pay a visit to the Foyle Valley Railway's excellent museum and take a ride on a genuine CDR railcar along over a mile of narrow-gauge track alongside the river?

Start this section of the old L&LSR's route at the new quayside shopping centre.

 Leave Derry city centre along the Shore Road heading north(ish) round all the roundabouts, keeping the new quayside to your right.

Underneath all the new buildings lies the old Lough Swilly Railway's Derry station at Graving Dock. It was an ugly, bothy-like affair which did little to enhance the prestige of the company.

 Further northwards the line ran into Pennyburn and it is there, at the Pennyburn Roundabout, that we turn left onto the A2 signposted for Buncrana and Letterkenny.

Hereabouts was the main workshop, loco shed and headquarters of the railway now largely swept away by the modern industrial estate and associated buildings.

As we travel along past new housing to our right and left the old trackbed was off to our right and has now completely disappeared. The Pennyburn Roundabout incidentally, marks where the railway's spectacular skewed level crossing traversed the Shore Road.

We proceed along Galliagh Road, past the new sports complex on our right.

The landscaping for this excellent community asset

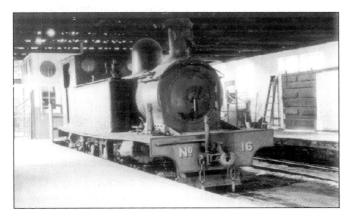

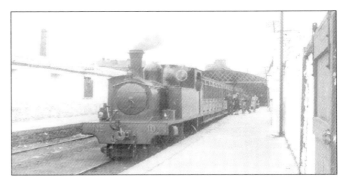

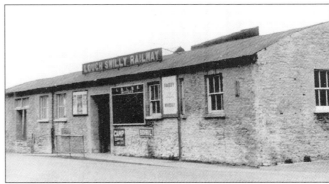

Left: Loco no 16 "in store" inside Graving Dock Station on the 24th June, 1937 – an unusual view showing the station roof, and there is a cloth tied over the loco's chimney! *Above:* **1** – No 10 about to leave with a train to Buncrana on the same day. **2** – The exterior of the station. *Both H C Casserley.* **3** – All that remains at Pennyburn today.

has wiped away any evidence of the old railway but as we leave the city limits we get our first sight of the old trackbed embankment rising a few feet out of the meadowland and running parallel with the road [418204]. Originally built to the wider gauge of five feet three inches the line took an easy path through these gently rolling fields as it headed north-westwards.

Again, unfortunately, apart from the distinctive straight line of trees and bushes on the slightly-raised embankment, there is little left of the old railway.

Soon we have crossed into County Donegal itself [404213] and, by the time we reach the roundabout [396218] we have passed the sites of the small wayside stations of Galliagh Road, Harrity's Road and Bridge End.

The Londonderry and Lough Swilly Railway

Bridgend to Buncrana
The Carndonagh Line

Tracing the route of the original section of the L&LSR is quite difficult as, in the forty-plus years since its entire closure, there have been many developments and changes to the local scene.

There are a few useful pointers to make a note of.

Firstly, as so much effort was put into getting a bit of flat land in what is often very rugged terrain you will frequently find houses built on the alignment of the old trackbed where the bedrock has been levelled and infilling compacted for well over a century.

Watch out for old gates, especially cast iron ones. You'll soon get the look of them. The railway was required to provide gates at every place the line crossed even minor farm paths and these were made of cast angle iron, often with triangular strengtheners at the corner. Once you've seen a couple of these venerable rusting relics then you'll soon be able to spot them all along the route.

Another useful idea is to keep an eye out for the post offices. When the railway was first built the postal authority usually established the local office at or next to the new station in each town and village. From its first days the railway carried the mails and so it was logical and convenient to have the collection and distribution point at the station.

Also, when the telegraphs and telephones were introduced the cables were often strung alongside the railway tracks and the exchanges sited at the stations. So there's always a fair to middling chance that wherever you find a post office in a rural community

once served by the railway then the station must have been close by, though, of course, the years have seen some changes and, as at Fahan, the post office has been moved to a more convenient site for the villagers.

A key point to remember is that the entire length of the old railway is now *private property* and *under no circumstances must you trespass* at any of the sites mentioned here. Also, please do not harass the present owners of the original station buildings. All of the railway relics listed here can be clearly seen from the public roadway.

And, the last of the finger wagging! Please park with care. Do not obstruct gates or other accessways to farms and fields. Obey the Highway Code and park safely. You can always walk back along the road to view and photograph that old railway bridge or station.

Oh yes, most of all, relax! *Glac go bog é* – take it easy. Enjoy the beautiful landscape of the Inishowen – a tranquil and charismatic part of a wonderful county in a stunning country. It may be sunny, it may blow, it'll undoubtedly rain; but that's what makes Ireland the emerald of the seas after all!

In sunshine and shadow
Bridge End to Buncrana

We begin our tour at the Bridge End roundabout at the point where the N13 is joined by the R238 [396218]

 At the roundabout we turn onto the R238, signposted for Buncrana and cross the railway's route from Derry. 100 yards from the roundabout you will see the entrance to Maxwell's of Donegal on your right.

The railway line crossed here at a level crossing. This is our first stop: Bridge End Station. We'll take a closer look.

The station house still stands in its original condition, only the small platform canopy is missing. Next to the station house stands the rusty waiting shed and, next to that, the old water tank.

Along the front of the building the platform edge can be seen while, on the other side of the level crossing

Below:
Bridge End Station House from the R238. The first station site of our exploration of the old line to Buncrana.

Long Ago on an Irish Railway

By Colonel H A Leebody

Quoted from the May 1939 edition of
The Railway Magazine.

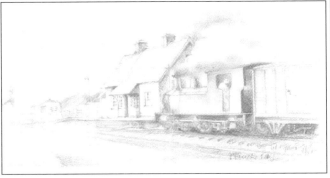

Bridge End Station

Various references in *The Railway Magazine* have recorded the position as it is today, but I want rather to speak of some sixty years ago. It was on the last day of 1863 that the first section of the line was opened for traffic. I was not to the fore at the opening, so I don't know how it went off. Somewhere in the line's early teens I first made its acquaintance and fell in love with the system. The locomotives and rolling stock were still very much as they were on making their début, perhaps showing a little wear and tear, as was natural. The gauge was the Irish standard 5 ft. 3 in., and the line, which was (and is) single throughout, then connected the City of Derry with the charming little watering place of Buncrana, or *Bun Cranagh*, some 12 miles away, on the shores of the Lake of Shadows. It formed a link between the wilds of Donegal and the less wild Maiden City. The track was constructed of flatbottom rails, spiked to the sleepers, and there was an absence of elaborate signalling or other modern railway working devices.

About half way to Buncrana, a short branch went off to the left to terminate at a pier called Farland Point, a distance of some three miles odd; from here a ferry service of sorts connected with Rathmelton and Rathmullen-small market towns. The point at which the branch went off was called " The Junction" – its more modern title is Tooban Junction. Personally I cannot remember this branch line in operation; it was abandoned and in a disintegrating condition when I first became interested. I well remember exploring the good-sized signal cabin, which stood near The Junction; it had even the remains of glass and fittings. At Farland Point one can still trace the remains of a platform, turntable, etc. The original stud of locomotives numbered three.

The method of train working while the branch line was in use was on this wise. One locomotive did all the work. The train started from Derry and proceeded by deliberate stages to The Junction. Shunting here having been freely indulged in, certain passenger and goods vehicles steamed away along the branch line to Farland, where those going down to the sea in ships with the merchandise were deposited. Those proposing to journey Derrywards were picked up, and after due shunting the modified train returned to The Junction, was re-shunted and rearranged, picked up the Buncrana quota, and set out for that terminus with somnolent sobriety. Now this matter of time to spare at The Junction brought out many devices.

Anglers sallied forth from the train, and getting out their rods, made good use of the then famous trout stream, close by the railway. The stream is still there if not the trout. I have heard my father tell of good bags made in this way while waiting to be carried to his objective, the fine rivers at Buncrana.

In the broad-gauge days the Derry terminus was situated right in the heart of the City, near the present Guildhall, and consisted of a wooden shed and one platform. It was dark and odoriferous. All manner of railway business was transacted by most obliging and friendly officials – porters in corduroys with scarlet band on their peaked caps, and guard with gold braided cap, white coated in the summer. Everybody knew everybody.

Let us, in imagination, take a trip from Derry by the forenoon train. Having got a ticket at an obscure, window, and worked one's way through a crowd of all sorts, one entered a third class carriage, open from end to end, but divided into compartments by low partitions, each compartment having its own doors. There were no cushions, and in the roof one oil lamp was to be seen. There were three classes, with the seconds distinguished from the thirds by cushions on the seats, but not on the backs. Here was always plenty of stir and bustle-boys calling out the names of passengers to whom they had instructions to deliver parcels, boys calling out the names of the local newspapers – finally a banging of doors and a call of "passengers take yer sates." After a prolonged whistle from the locomotive the train pulled out with a sort of concertina action of loose couplings, and we were off for the dreary trundle along the quays at a speed of say four miles an hour, with prolonged modulated whistling at frequent intervals to warn pedestrians. Having reached Pennyburn, where the train arrived by crossing the Strand Road through big iron gates … a halt was called at a platform in close proximity to the running sheds; here the engine took water. After due deliberation a start was made up a fairly stiff incline on the journey proper.

The three original locomotives were 0-6-0 tank engines, two side tanks, and one saddle tank. The former had outside cylinders, the latter inside. The side tanks had a very flat squat appearance, low set boilers, high chimneys with splayed caps, and a high dome with a safety valve on the middle ring of the boiler. The windscreen was straight up, and just a little above the level of the heads of driver and fireman. The saddle tank had a stovepipe chimney, a straight weatherboard, and the entrance for the driver over the middle of the rear buffer beam. On the re-gauging of the system in 1887 the two "flat" engines were scrapped, and the "coffee pot " was purchased by the Londonderry Harbour Commissioners, and acted for years as a shunter on the quay.

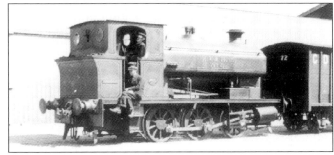

"The coffee pot", shunting at Derry in 1937. *H C Casserley*

In June, 1883, the narrow-gauge (3-ft.) line from The Junction to Letterkenny was completed and opened for traffic. At The Junction an island platform served to accommodate trains of both gauges, the broad gauge (5 ft. 3 in.) along one side, and the narrow gauge (3ft.) on the other. Everything had to be transhipped here, and this was of enthralling interest to us as youngsters. For some years this different gauge system was worked, but as one might expect it was found most unpractical, and in 1887 – with remarkable energy, and in record time – the Derry-Buncrana section was converted to 3 ft. and the system became uniform. The broad gauge "coffee pot" shunting engine of the Harbour Commissioners had a third buffer fitted … the system in operation was that the Commissioners' engine took over the train near Pennyburn, and on the outward runs handed over to the Lough Swilly engines at the same point. (*abridged*)

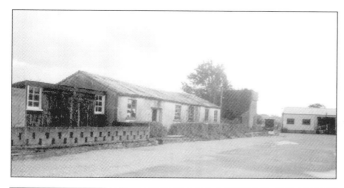

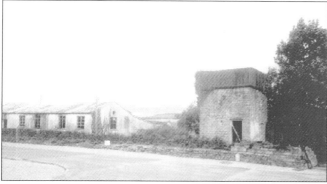

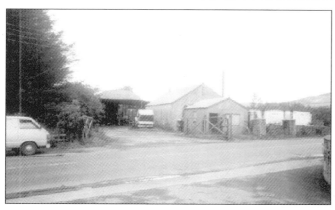

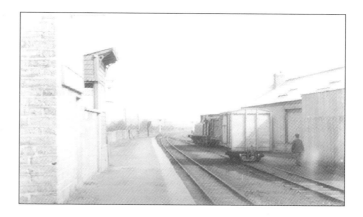

across the road, you'll see an original L&LSR green hut.

On the day of our visit a local worker told us that the green corrugated iron hut was originally used by the railway but, on closure, it became a tailor's shop where suits were made up from material smuggled in from Derry across the border, a few yards away! When the cutting and sewing was complete the finished suits were then smuggled back across the border – all to avoid the duty!

Cloth was just one of the many items smuggled across at this point and elsewhere; the stories are legion of butter, eggs, cream, ham – you name it, it got moved!

This was especially popular during World War II when Northern Ireland faced severe rationing while those experiencing "the Emergency" in the Republic often had plenty of foodstuffs but little fuel.

Many people will tell you stories of making illicit purchases while "down south" on a day trip and then, as their train approached the customs check, they would hang them out the opposite window on a piece of string. The traffic ran both ways and, to be fair to the officials, they often turned a blind eye to what was, after all, helping everyone get through desperate times.

 Follow the road round into Burnfoot where little, apart from well-overgrown trackbed, remains.

 Continue straight on through Burnfoot and, as the road bears left look for and take the minor road on the left signposted (a small sign, don't miss it!) for Inch [378238].

As you travel along you can just make out the raised embankment of the railway off to your left with the small river Burnfoot between it and the road.

A little way further, and completely indistinguishable when you look from the road, is the site of The Junction [363245]. This was a very simple affair with no substantial buildings as it was located on embanked reclaimed land in the Y formed by the Burnfoot and Skeoge rivers coming together. It never had road

Above, top to bottom:
1 – Bridge End Station buildings. **2** – The waiting shed and the water tower as still in position. **3** – The ex-railway building later used as a tailor's. **4** – The level crossing at Bridge End. The gates, though attractive, are not, unfortunately, original. ***Top left:*** Bridge End Station in 1953, looking towards Derry. Some vans are being shunted. Note the signal box at left with the sloping roof. This was a characteristic Swilly pattern. *H C Casserley*

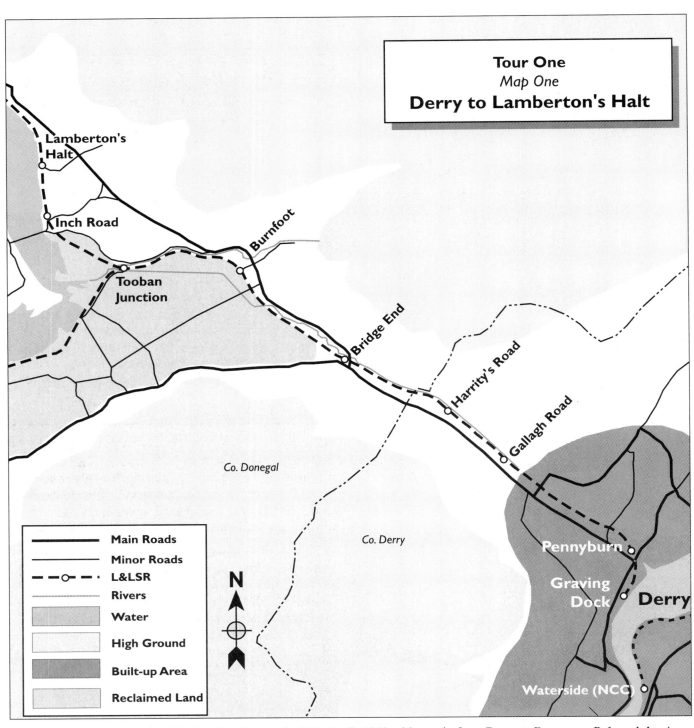

Lamberton's Halt

Inch Road

Burnfoot

Tooban Junction

Bridge End

Harrity's Road

Gallagh Road

Co. Donegal

Co. Derry

Pennyburn

Graving Dock

Derry

Waterside (NCC)

——————	**Main Roads**	
————	**Minor Roads**	
– – ○ – –	**L&LSR**	
	Rivers	
	Water	
	High Ground	
	Built-up Area	
	Reclaimed Land	

N

Below left: No. 3 approaches Tooban Junction on the 20th April, 1953 with a train from Derry to Buncrana. *Below right:* A general view of the Junction from the north-west end showing the signal box and goods store. Both H C Casserley.

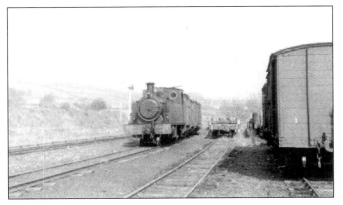

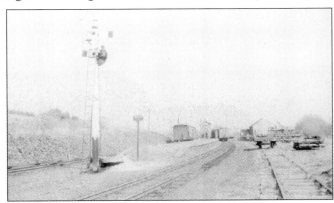

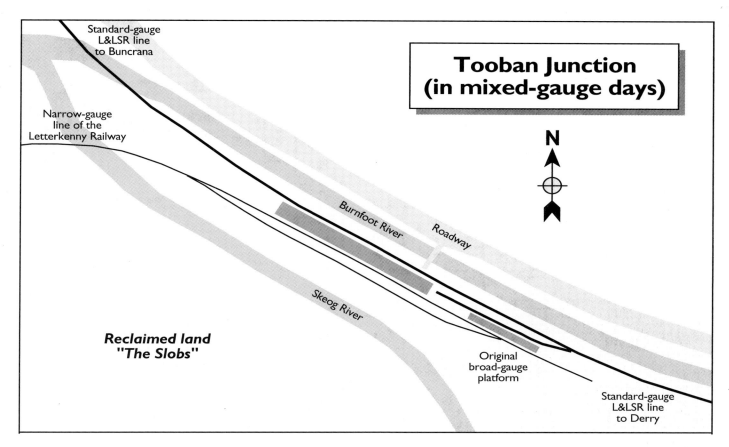

Two diagrams showing the development of Tooban Junction. Above is the layout as it existed during the days of the 5' 3"-gauge line from Derry to Buncrana. The original Swilly line to Farland Pier made a junction here and the original trackbed was reused by the narrow-gauge Letterkenny Railway when it was built as far as this point. The facilities here were always rudimentary, basically just a transfer platform for the use of railway staff moving parcels, post and other freight. Below is the Junction in its final form with all the lines now narrow-gauge.

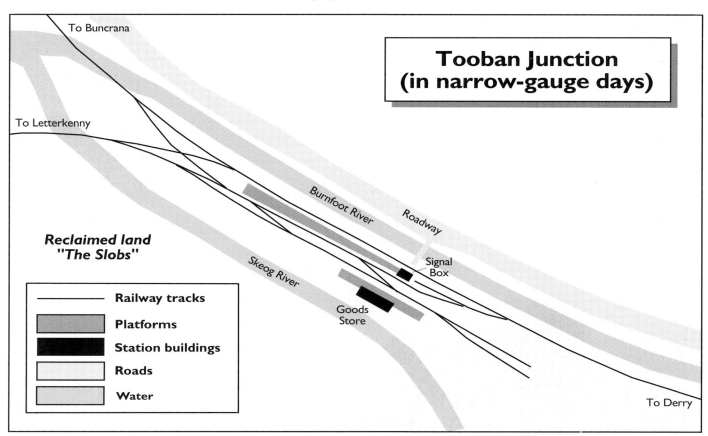

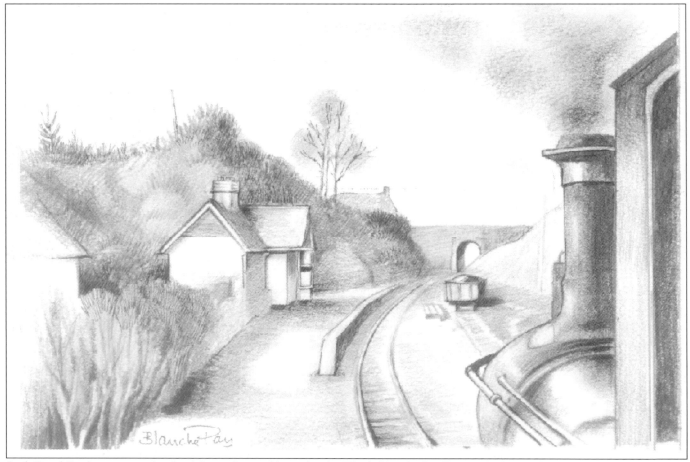

Inch Road Station, as seen by the driver of a southbound train. The bridge in the distance is our modern viewpoint.

access, and still doesn't!

The Junction was later known as Tooban, a transliteration of the name of the local village of *Tievebane* and was where you could change from your train from Buncrana to one heading to Letterkenny (and vice-versa, of course!).

This type of remote, inaccessible junction is a characteristic of Irish railways and there were several similar examples – Manulla Junction exists to this day.

So, then, The Junction, hidden somewhere in amongst the shrubbery and reeds marked the spot where the original L&LSR line turned south-west, originally to end at Farland Pier [333223] from where a steamer service was projected.

Below: The railway embankment from Tooban Junction, opposite the bungalow.

As railway communications developed it was revitalised as part of the route of the Letterkenny Railway and was always the busiest section of the old railway.

The line to Buncrana and beyond turned north-west here and, continuing on our little road, we can see the railway embankment swing in from our left-hand side and cross the road just at a bend to the right [352241].

Stop opposite the bungalow – please park with care.

You can still just about see the remains of the old railway overbridge abutment in the foliage to the left. Across the road the route is now a private accessway – no trespassing please!

Now we can proceed.

Follow the road to the minor T junction, turn right and climb upwards and to the right until you see the parapet walls either side at the top of the rise. Park with care.

This is another road overbridge. The railway came from Tooban Junction through a cutting, under this bridge, and into Inch Road Station to the north [349243].

From the bridge northwards the cutting has been filled and modern bungalows built. Nothing now remains of the station which once served Inch Island as well as

Top left: the site of Inch Road Station. *Middle left:* Lamberton's Halt, with platform intact, as seen from the road overbridge. *Bottom left:* looking north from the Halt, note the original L&LSR gates and the course of the line along the shoreline towards Fahan. *Right:* Mr Lamberton's Halt still evokes the days of steam trains. The overbridge is well preserved.

the immediate neighbourhood. Cattle were a regular load from here as well as local farmers and their families for the markets and shops of Derry.

 Proceed forwards. Keep left at the minor junction and turn left back onto the R238.

Towards Lough Swilly the line is hugging the shoreline – its preferred route right through to Buncrana.

 About a mile along the R238 is an unmarked minor road to the left leading to the farmsteads in the area known as St Mary's [355244].

If you do decide to do this little bit of the old railway please be especially careful about not blocking the roadway or gates as the road is an important access route for the farmers.

 Proceed to the bottom of the road and bear round to the right. Stop in the yard and park with care. If asked to move by the farmer, do so immediately.

Get out and walk along the roadway by the side of the farmhouse to the bridge parapets. The line came up from Inch Road Station to the south and passed underneath onwards to Fahan. On the Fahan side are the remains of a small platform. This is Lamberton's Halt. The farm is the Lambertons' farm.

Mr Lamberton can clearly remember the day in the 1920s when the halt was built. Before then, he, his parents and neighbours would walk along the railway track to Inch Road to catch the train but his father asked the railway's general manager to provide a halt at the end of their field.

The site was duly inspected and approved and, within a week the work was done! A stile on the east side of the bridge gives access. All the stonework is in excellent condition and the bridge is as strong as it ever was – a fine tribute to those local builders who put such care into their work. There are steps down on the shore side of the bridge but these are slippery when wet and a sheep fence protects the field on the railway side.

Walk back over the bridge to the shoreside and you can make out the route northwards right along the edge of Lough Swilly.

 Back to the car, turn round, up to the main road and turn left.

The railway is now hidden away below us on the shore's edge but we are soon going to see our first major survival of the days when the steam trains puffed along the loughside.

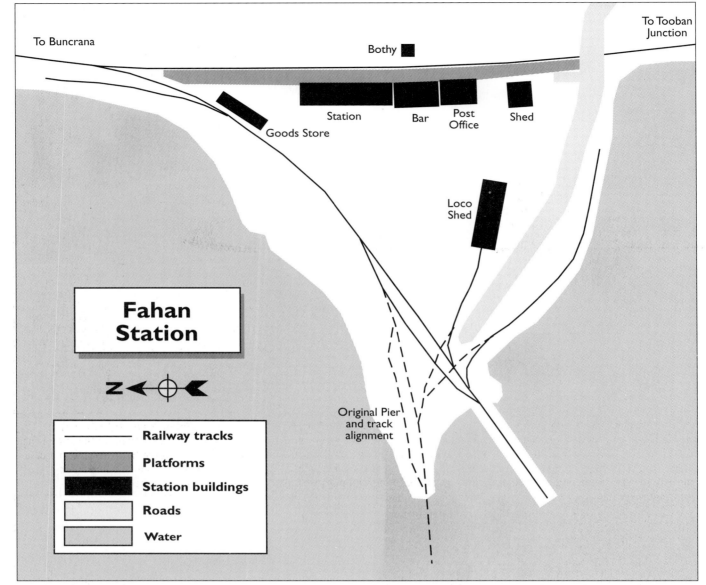

The layout at Fahan Station. The pier – and bar – were often busy spots as the steamers connected with the trains so as to take passengers on to Rathmullen, Ramelton and Portsalon.

 Watch for the signs for Fahan. Travel through most of the village but keep a sharp lookout for and turn down a minor road to the left which drops down to the water level signposted for the strand [337268].

As you drive, slowly, you pass across a road overbridge and then drop steeply down to the strand.

Drive to the mast at the end and park.

You are now on Fahan Strand. Marching out into the lough are the remains of the 1922 railway-built wooden pier with a crane at its end. The original pier projected out from where the more recent concrete slipway has been built near the mast.

Look back to the land. On your right the railway's route is very distinctive with the buildings and caravans of the Lough Swilly Yachting Club standing on the trackbed. On the left the trackbed continues along the shore. Directly in front of you is the road you drove down with a railway bridge in fine condition, a restaurant, a couple of houses and a large grey-painted stone building.

Walk between the houses and the restaurant. The grey building was originally a coal store and was then bought by the railway for use as a loco shed. You can still see the notches in the stone at the entrance door where the rails were once laid – three foot narrow gauge, in case you're wondering. The Swilly's line was entirely converted to narrow gauge by 1885.

Past the grey shed and up to the old railway's trackbed. To your right is the bridge. On your left is the original station, now reclad and with modern windows. The tall end gable was a separate establishment – the local post office. The white-painted section at the end is a modern addition.

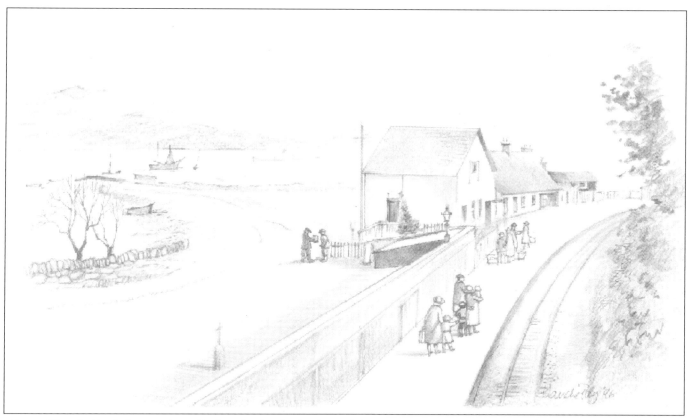

Above: Blanche Pay's impression of Fahan Station in the days of the Lough Swilly Railway. ***Below upper left:*** the road overbridge carrying the side road down from the main coastal road, station wall to right. The cars are parked on the site of the platform. ***Below lower left:*** the station building with the old post office at the end. The building nearest the camera is a recent extension. ***Below upper right:*** the remains of Fahan pier. ***Below lower right:*** originally a coal store, then adapted by the railway to serve as an engine shed and now used for commercial purposes. Note the grooves in the doorstep.

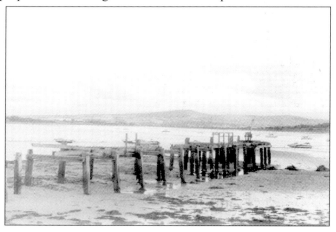

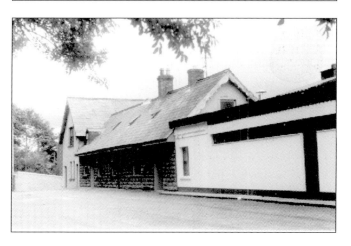

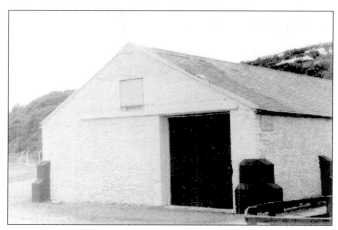

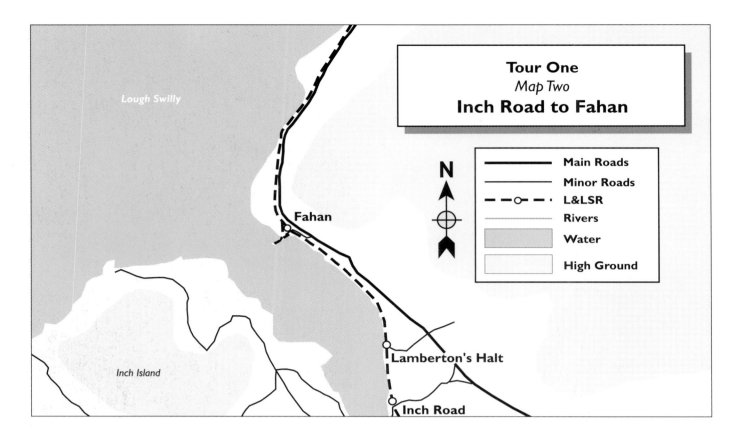

It's very clear where the tracks came through. There is part of the old station wall at the north end. Beyond the wall a siding swept back towards the pier and ran right along it for loading and unloading straight from the steamers onto railway wagons. Two sidings then led off that siding from the pier: into the loco shed, and along the southern side of the strand towards what is now the yacht club.

Use the plan to get an idea of just what the layout was like.

In days gone by railway-owned paddle steamers called here and connected with Rathmullen, Ramelton and many other piers and quays around the north of the county. With names like *Innishowen*, *Lake of Shadows* and *Kate* they provided an important communications and transport link up and down the many convolutions of Lough Swilly. The L&LSR always tried to combine as many types of transport as possible to provide a real integrated network long before the term was ever coined by the economists.

 Back in the car and up to the main road again for a very tight left turn onto the R238 to Buncrana.

The railway continued along the shoreline all the way through to our next stop. Just north of Fahan is a short deep cutting through solid rock – a very photogenic spot in the days of steam railways [333273]. To photograph it today you'll need to pass it, park, get down to the sandhills and walk back a bit.

You should also notice the golf course, to your left.

When the railway was running the south end of the course was served by a wooden platform named Beach Halt and, about half-a-mile further north nearer to the club house, was Golf Halt, later renamed Lisfannon Links.

Golf Halt had a real DIY signalling arrangement, not uncommon in those far-off days. A simple semaphore signal was erected and could be raised whenever any passenger wanted a train to stop!

And so on to Buncrana, the biggest and most distinctive station on the line, as befits the destination of so many day trippers and holidaymakers from Derry and beyond. The railway's route was right next to the road here but widenings and new developments have practically eradicated any trace.

Coming into Buncrana you just cannot miss the station!

Standing on the left side of the road this magnificent steeply-gabled two-storey building is now the Drift Inn bar but still proclaims "railway" as soon as you give it a closer look [346314].

 There is a turning to your left at the far end of the building right next to some large tourist-facilities signs and opposite the petrol station.

Pull into the old station yard (actually on the site of the main lines between the platforms) and park.

Buncrana Station

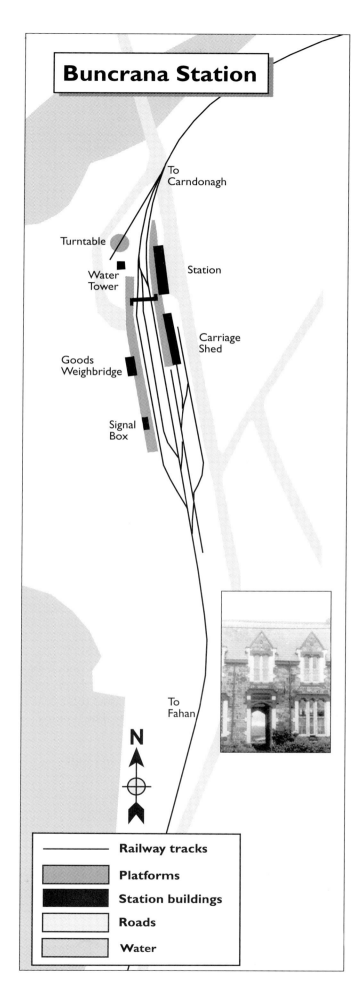

To Carndonagh

Turntable

Water
Tower

Station

Carriage
Shed

Goods
Weighbridge

Signal
Box

To
Fahan

N

——— Railway tracks

Platforms

Station buildings

Roads

Water

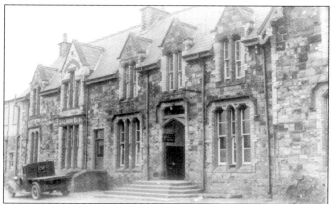

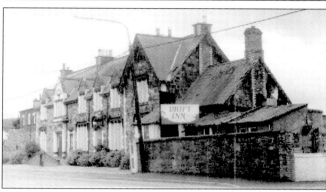

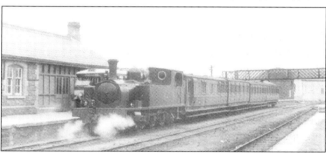

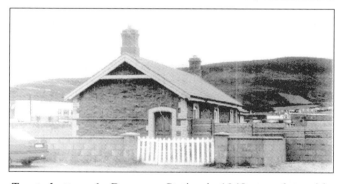

Top to bottom: **1**– Buncrana Station in 1948, complete with period car. The photographer, H C Casserley, was standing with his back towards the level crossing where the line to Carndonagh crossed the road and headed northwards. **2** – The station as it stands today a.k.a. *The Drift Inn*: a wonderful survival from the days of steam. **3** – Again, in 1937 with a Derry-bound train about to leave from platform 2. The goods weighbridge and office can be clearly seen together with a connecting bus conveniently parked on the platform. **4** – The goods office today, beautifully restored and now a private residence. ***Left:*** the passenger entrance to Buncrana Station is still much as it ever was. You can still walk through and imagine yourself about to catch a train to Ballyliffen, Clonmany or Carndonagh.

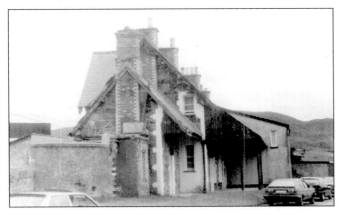

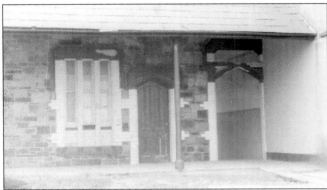

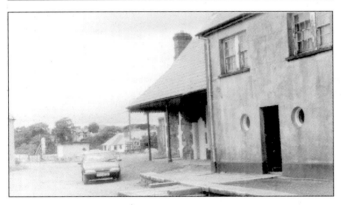

Top: the north end of Buncrana Station. the cars on the right are parked just where the tracks would have been. *Middle:* the passageway to the street is on the right and the ticket window, still practically intact, is in the centre: "Return to Derry, please!" *Above:* the building on the right with the two "portholes" is a post-railway extension to the Bar but some of the platform and the awning still remain in place after all these years. Buncrana Station is a real gem!

Yes, it really is still standing! Amazing! Let's take a deep breath and dive in.

The rear side of the building shows the modern additions, of course, but most of it is practically unchanged. To the left is the gentlemen's loo, then an office (perhaps the "lamp room") and then the staff rooms and ticket office. Right next to the modern extension is the passageway for passengers entering and leaving. The ticket office window still retains the wooden shelf. The platform height has been retained by and large and some bits of it remain.

Behind you, between you and the golf course is a large building with windows long concreted up. This, we believe, was a private goods store of some sort – it certainly appears, with windows, in the earliest photographs that exist of the station.

The water tower (minus cast-iron tank) is clearly visible alongside a corrugated iron shed with a curved top, could this be the old telegraph company's shed?

Further back, near the golf club house is the beautifully-restored goods weighbridge office, now a private residence. Round at that end of the station is a long, low roughstone building, originally a carriage shed and now an off-licence!

Incidentally, you may have noticed the modern building at the point where you turned into the station yard. This is a public weigh station. So, as with the post office at many places, the original site for weighing freight vehicles has been retained in Buncrana, albeit shifted to the other end of the old station and now used for road lorries.

Walking down the south side of the station building itself try and make out the oldest "new" addition to the original building, up by the end gable. This was the original Railway Bar, a separate establishment but, no doubt, a vital part of railway work.

Cross the main road and look at the station frontage. The original building is practically untouched from this side angle, proudly proclaiming "established 1863". It's well worth a photo. Note the distinctive L&LSR brickwork and decorative elements to the windows, we shall see them again further north.

The Buncrana and Carndonagh lines' buildings were noted for their fine construction and elegant appearance.

The entrance steps have been slightly altered since the building's railway use ended. Originally there was a short flight up to the left-hand door to the stationmaster's residence while, on the right, a much wider flight led up to the passageway.

Now cross and step back through time and walk through the passageway, turn right and order your return ticket for a day's shopping expedition to Derry or a single to some wild and remote spot like Ballyliffin or Rashenny.

Take your time and enjoy the experience. Buncrana Station is a great survival from the golden age of steam railways. Go in, have a pint, enjoy yourself!

When you're ready to proceed then we'll head north again, up into wild moorland, mountains and seascapes as we trace the railway's route right through to Carndonagh.

Tour One
Map Three
Beach Halt to Cochrane's Siding

Cochrane's Siding

Drumfree

Kinnego Halt

Ballymagan

Buncrana

Golf Halt

Beach Halt

N

——— Main Roads
——— Minor Roads
– –○– – L&LSR
········· Rivers
⬚ Water
⬚ High Ground

'midst the turf and the surf
Buncrana to Carndonagh

Suitably mesmerised by finding such a wonderful reminder of the old Lough Swilly turn left onto the R238 again and follow the signs through the town.

By the way, just before pulling out onto the road, the railway crossed it just here, at the north end of the station and ran off across what was then open fields. A line of new bungalows stretching away almost at right angles after the garage sit on the old trackbed – good foundations made to last!

When you come to the mini roundabout at Buncrana continue straight over on the R238.

After leaving the town the railway runs about a quarter of a mile away to our right then swings further away across the fields and moorland.

About four miles out from Buncrana you can just see a solitary and remote small building on the right, looking towards Kinnegoe – the old crossing house and "station" [375361]. It is now derelict and the only evidence of its railway past is a familiar bit of iron gate and a straight line of lighter moorland grass

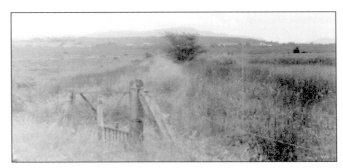

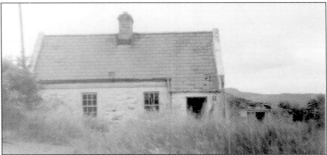

Top: the trackbed stretching across the turf moorland from Buncrana. ***Above:*** Kinnegoe crossing house.

heading back towards Buncrana. It was opened as a halt in 1930.

If you want to visit it turn off on the minor road to your right at map reference 374366.

Watch out for the ghost train of Kinnegoe Gates!

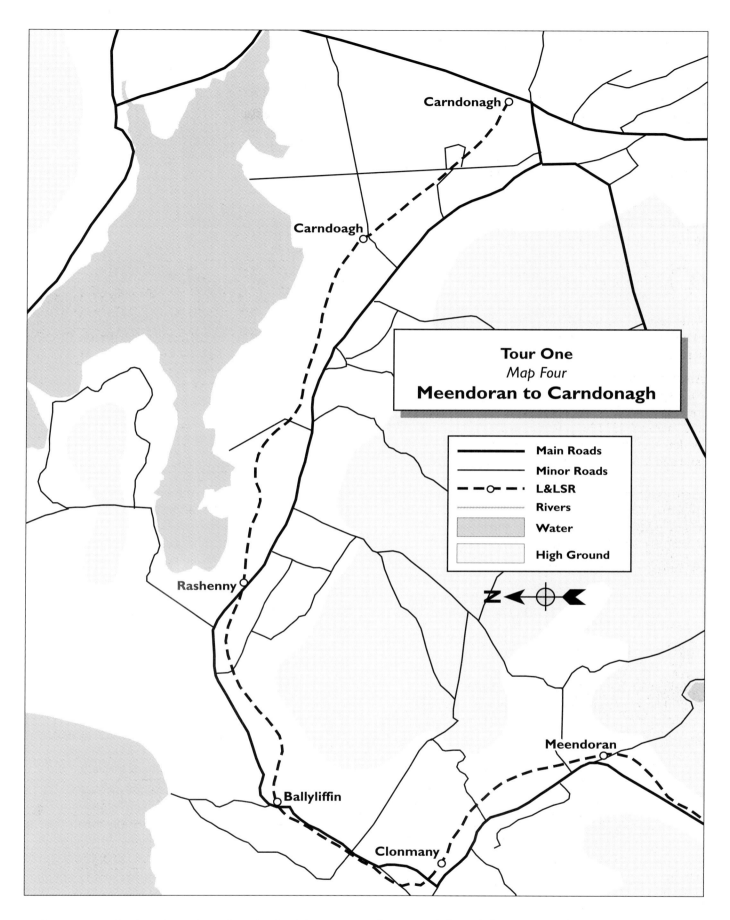

Tour One
Map Four
Meendoran to Carndonagh

Carndonagh

Carndoagh

Rashenny

Ballyliffin

Clonmany

Meendoran

Main Roads
Minor Roads
L&LSR
Rivers
Water
High Ground

Back on, or continuing along the R238 the familiar railway embankment, marked by the continuous line of bushes and trees on a raised level trackbed swings in from our right and then crosses the R244 at Drumfries [385390]. This is a fast junction so be careful!

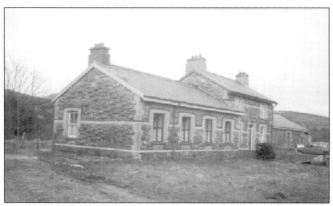
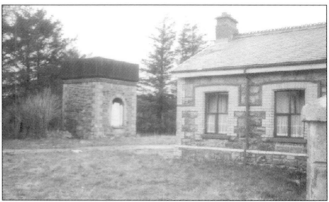
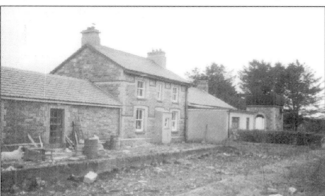
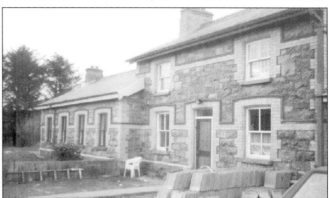

All above: Clonmany Station as it appears today. The two-storey central building is the old stationmaster's house, the single-storey section this end is the ticket office while the goods office is at the far end. The water tower still stands and the two platforms are visible at the rear. The station buildings have been beautuflly maintained, a real credit to the present owner.

The old station has now been incorporated into a bar (it seems this is an excellent local traditional way of ensuring the continuation of fine old railway buildings) – the *North Pole*.

You can see a gateway on the east (right-hand] side of the R244 immediately at the junction. The railway came up from near the river Owenboy here and ran behind what is now the bar, through the owner's back yard.

Keep on the R238, the leftward road.

Driving on we pass Mintraghs Lough. The railway's route has swung away from the road and can be occasionally glimpsed on the far side of the lough [385404].

Just to the north of the lough is the site of one of the few private freight sidings on the railway: Cochrane's Siding. This had a loading bank for shipping stone. A bank is still to be clearly seen from the road as you pass [381409].

The railway then swung back to the roadway and ran alongside it for about three miles. Indeed, if you look carefully you can see that several of the little bridges that the road uses have different parapets on left and right showing that two bridges have been joined when the road was widened in the early 1960s. In fact, it looks as if the road and railway bridges have been simply combined as they ran so closely together through this narrow pass.

At a long straight section of road you get a good glimpse of the beginning of the Meendoran Viaduct on the right where the railway parts company from the road and crosses to the other side of this high valley [386438]. With care you can park here, walk back a few yards and photograph the first arch. All of the rest and much of the trackbed is obscured by pine trees.

Now we come to a section where there is little evidence remaining. The railway remains on our right then crosses the road at Clonmany [376463] as we turn right towards Ballyliffin.

To locate Clonmany Station turn right just at the 30 mph signs befor entering the village. You will then see a spread of three roads, take the middle one. The station is private property so park carefully near the gate posts and view the station from there.

The station is very well preserved and has been maintained in a way that really enhances its unique architectural antecedants. The station house, offices and goods office are still intact and the water tower is still standing.

Now retrace your route to the main road and turn right and follow the road through Clonmany village.

Proceed along the climbing road to Ballyliffin and, after passing the Ballyliffin Hotel on your right stop at the Post Office on your left.

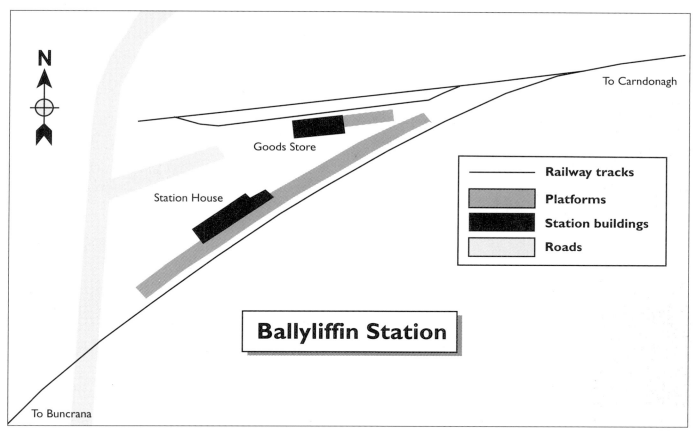

Ballyliffin Station

To Carndonagh

Goods Store

Station House

To Buncrana

Railway tracks — Railway tracks
Platforms
Station buildings
Roads

If you have stopped just right then by simply looking across the road you should clearly see the end gable of Ballyliffin Station, now a private residence [382482]. Again, this fine building is in the characteristic brickwork with the decorative window framings and, having stood for so many years, is still in fine condition. It is a real gem. A compact, concise essay in rural station architecture. The original goods shed is still standing, a trailing siding sweeping in from the Carndonagh end of the station.

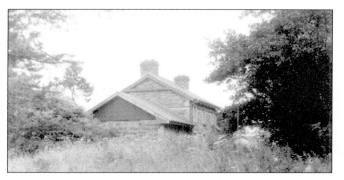

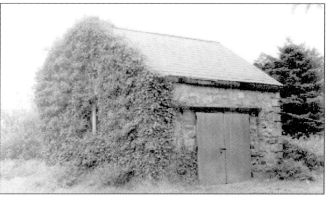

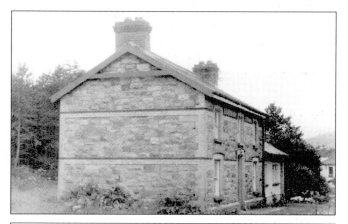

Upper left: Ballyliffen Station, as seen from the main road. *Lower left:* The goods store, almost reclaimed by the undergrowth. *Upper right:* The station house, note the fine brickwork – a characteristic of the stations on this line. *Lower right:* the Meendoran Viaduct, now almost entirely lost amongst the trees.

Back on the road and we proceed round past Doagh Island, the site of Rashenny Station and on to Carndonagh.

The railway was first on our right after Ballyliffin but crossed over to our left after a couple of miles [412486]. Again, little now remains of the old trackbed except for the occasional stretch of characteristic curving lines of trees and bushes.

And so into Carndonagh!

Go on past the shopping centre (an old cinema?), climb the steep hill to the crossroads and turn left along to the main shops. Then back down the hill, still on the R238, signposted for the fire station.

As you run down the hill past the houses towards the flat river plain you'll see some industrial buildings on your left. Turn into the yard on your left and, behold, Carndonagh Station awaits your camera! [471454]

Now the home of Atlanfish, Carndonagh Station is another gem of the railway builder's art.

The original station offices and agent's house still stand, as do the loco shed, carriage shed and goods shed. Please call in at the office (the old ticket office) to check that it's OK to wander around – note the L&LSR timetable framed on the wall. Then just set off, plan in hand and explore.

Atlanfish has been particularly sensitive in keeping as much of the old station's character as possible given that a modern commercial fish-processing operation is now based here. Part of the old platform remains and modern brickwork marks where much of the rest once stood. On our visit it was possible to look into the carriage shed – now fully-fitted for the processing work. Be careful of the enormous lorries that now use the station environs.

Walk down to the old station throat and you'll find the loco shed still standing and still used by the Londonderry and Lough Swilly Railway Co. Ltd – as a store for road grit. The modern doorway appears to have been punched through the original blank end wall.

Indeed, at several of the station sites it's *still* possible to catch an L&LSR service – the company's buses

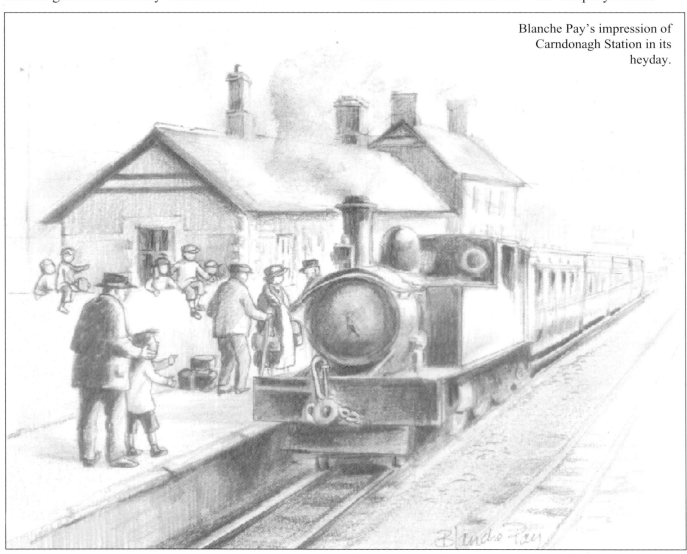

Blanche Pay's impression of Carndonagh Station in its heyday.

Carndonagh Station

Below: Carndonagh Station, now the home of Atlanfish but still easily recognisable as a railway terminus. Much still remains here but do ask permission before wandering around.

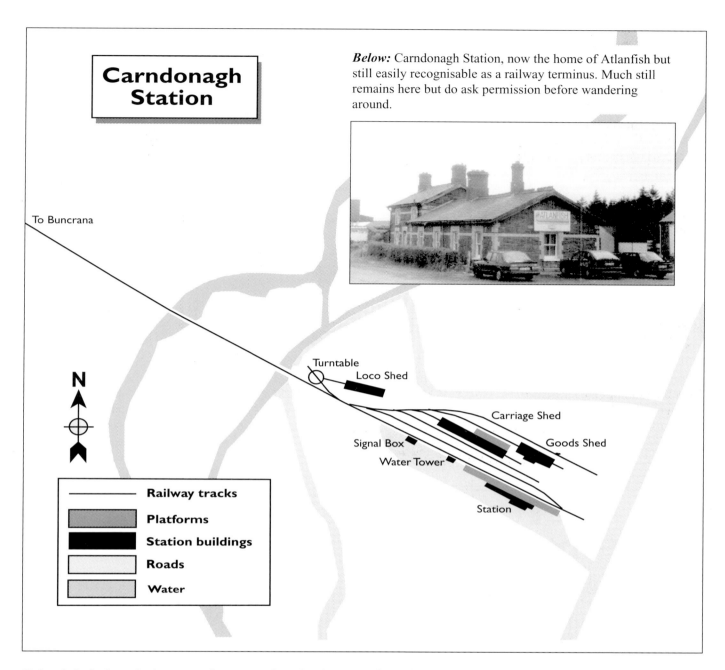

To Buncrana

Turntable
Loco Shed
Carriage Shed
Goods Shed
Signal Box
Water Tower
Station

N

	Railway tracks
	Platforms
	Station buildings
	Roads
	Water

Below left: the loco shed, now used as a store for grit. It's appropriate, of course, that a Swilly bus should be parked alongside! *Below right*: the loco shed showing the original rail entrance. The carriage shed is in the distance.

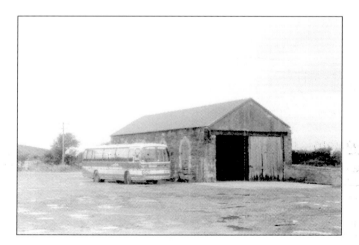

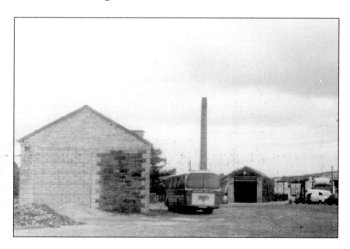

connect up all the old stations and many more places besides: one of the few successful transfers from rail to road (and commercial survivalship into the bargain) that we can think of.

So, when you pass one of the Swilly coaches, give them a friendly wave. It may be tarmac rather than iron roads but the company still provides a vital passenger and freight service to a vast part of County Donegal and beyond.

Back at Carndonagh there's a poignant reminder of times now past. At the spot where the line back to Buncrana crossed a small stream there's a wall stopping people falling in or trespassing with the single word "Closed" painted on it.

Closed and gone, yes, but not forgotten.

As you make your way back through the mountains and moors of Inishowen choose a quiet place to stop. Turn the engine off. Wind down the windows or, better still, get out and just listen. There it is, in the distance, behind the wind. The ghost of a sound. The whisper of an echo of an engine's whistle.

Like a silent wraith wrapped in steam, the spirit of the Lough Swilly Railway still passes the old stations and runs along the mountain side in a magical reminder of times past.

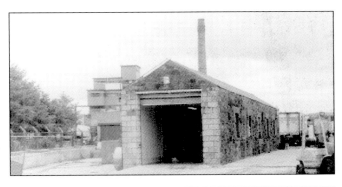

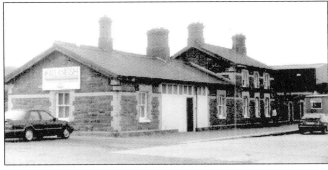

Top: The stone-built carriage shed which, together with the goods shed beyond, are now in use for fish processing purposes. *Above:* the single-storey building was the original ticket office while the tw-storey section was the agent's house.

The Swilly and the Letterkenny Railway

Tooban Junction,
Newtowncunningham,
Pluck and Letterkenny

Out amongst the slobs
Tooban Junction to Manorcunningham

The Tooban to Letterkenny leg of our journey should really start at Tooban Junction where the lines from Derry, Buncrana and Letterkenny all converged.

However, nothing remains at Tooban Junction today and it's practically impossible to pinpoint the exact location of this important but inaccessible junction amidst the reeds, brush and undergrowth that have engulfed the site since closure and dismantling of the railway.

The Junction was squeezed in between the Burnfoot and Skeog Rivers on a narrow strip of land completely lacking road access, only a path and bridge over the water made it possible for staff to gain access from the nearby minor road to Inch Island.

Tooban was just a basic crossing point on the edge of a large area of reclaimed land known locally as the slobs. The station consisted of an island platform between two lines of track, a goods and permanent way store (a bothy) and a signal cabin at the end of the platform. The single line track from Derry approached from the south east and split to pass either side of the signal cabin and platform. At the northern end a scissors crossing reconnected the two lines which then curved sharply away from each other heading respectively to Buncrana and Letterkenny.

Tooban signal cabin was a real haven in this bleak spot and many an engine driver, fireman and guard found a welcome cup of tea there in the only substantial building capable of affording shelter against the icy winds of the Atlantic gales that blow up Lough Swilly.

If you wish to be precise and start your journey actually at or near Tooban Junction then you will find it half way along the side road from Burnfoot village to Inch Island at map reference 361235. It's also mentioned in our guide to the Buncrana and Carndonagh line.

You'll need waders, thick gloves and an air of quiet desperation and dogged determination to even get to the bankside – we don't recommend it!

However, we'll let realism prevail and commence our journey in Burnfoot village [382235].

 Drive south through the village on the R238 heading towards Derry. Turn right at the first road just past the village, signposted for Letterkenny [383233].

About 100 yards down this road you'll see two green-painted grain silos on the left. The Derry – Tooban line crossed the road here on a level crossing just before the silos themselves.

If you look carefully you can still see the crossing point.

You are now on a long straight road. It's about a mile long and makes its way through very flat reclaimed slob lands. On some maps the road is marked as, yes, you've guessed it, "Slob Road"! Not a pretty name but an apt description of the ground around here, especially if you get your foot stuck in it.

 At the end of this dead straight road there is a very sharp right-angled corner to the left.

Stop safely near here just before the corner and look to your right. At the end of a narrow laneway you'll see a large embankment crossing at right angles.

This is the Trady Embankment, one of three such embankments built along the coastline to reclaim land and prevent the tidal flooding of the low slob lands. Two further embankments were constructed across to Inch Island to control tidal floodwaters.

Below: The view along Trady Embankment from Farland Point towards Inch Level [335218].

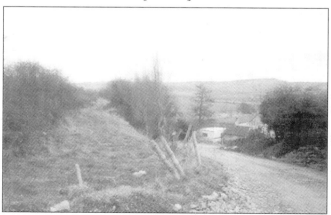

The railway track ran along this embankment just after it left Tooban Junction and stayed on it for about two-and-a-half miles to Farland Point.

In this area the land is so fertile and productive that the track bed of the old railway has been levelled into the fields wherever possible to make it suitable for cultivation. So, if these embankments hadn't survived by doing such a useful job there would be very little evidence of the Swilly's existence in this area.

And, of course, when these embankments and dykes were first built they made an ideal route for the railway and the actual construction of the trackbed was that much easier.

The slobland area is also a wildlife reserve. If you visit the area in the autumn, as we did when making this survey, you'll find a large variety of geese and other wading and shore birds who have flown here to spend the winter on the shores of the Lough. For several miles in either direction you can hear the continuous noisy chatter and squawking of the geese: it's just like a rather large political convention! Spring and summer also have their attractions as birds breed, nest and raise their young here.

Anyhow, enough of the wildlife, let's resume our journey back in time.

Now just where did we leave the car? Ah, yes, we were parked near the sharp left-hand corner.

 Back behind the wheel, continue around the corner and make your way up to the main road, which you should see up ahead. This is the N13, the main Derry to Letterkenny road.

As you approach the junction you will see a round stone church on the other side of the main road. On the hilltop (Greenan Mountain) behind the church you can see *Grianan na Aileach*, the finest example of any preserved stone ring fort in Ireland. There are beautiful views of both Lough Swilly and Lough Foyle from the fort. It's well worth a visit and will give you an excellent idea of the countryside that the Lough Swilly Railway ran through and perhaps you'll be able to trace its path in the landscape if it's a fine day. But, in order to keep close to the scent of the railway's route, we'll save our visit for another day.

So, there you are, patiently waiting at the T-junction opposite the church while we blather on.

 Turn right towards Newtowncunningham, Newton for short, and drive for about three-quarters of a mile.

Just past the post office turn right (355201). There is a parish hall opposite the junction.

This small road leads down to Trady Point and, eventually, Farland Point.

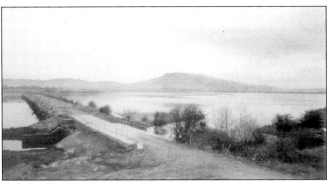

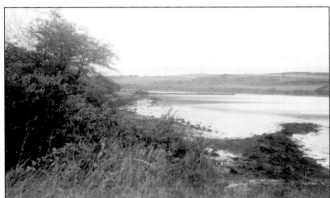

Top: Farland Embankment, Inch Island is in the distance. (335218) *Middle:* Farland Point, the remains of the old pier can just be seen stretching out in the distance. (334224) *Bottom:* The castle on the point of Inch Island as seen from the old pier. This view is looking westwards out to the main body of Lough Swilly (323224).

This is a narrow road but a fairly straight one with a sharp left-hand bend, located at Trady Point.

 Drive along the second straight stretch and, as you round a right-hand corner you will see a house at the end of the road [335218]. Drive past the house and up the little hill, a matter of a few yards.

This "hill" is actually the side of the railway embankment and you are now on the trackbed, a favourite spot for fishermen to park their cars. There is a great view of Inch Island across the point. Farland Embankment stretches out like a ribbon to your right and Farland Point itself is on your left just out of sight.

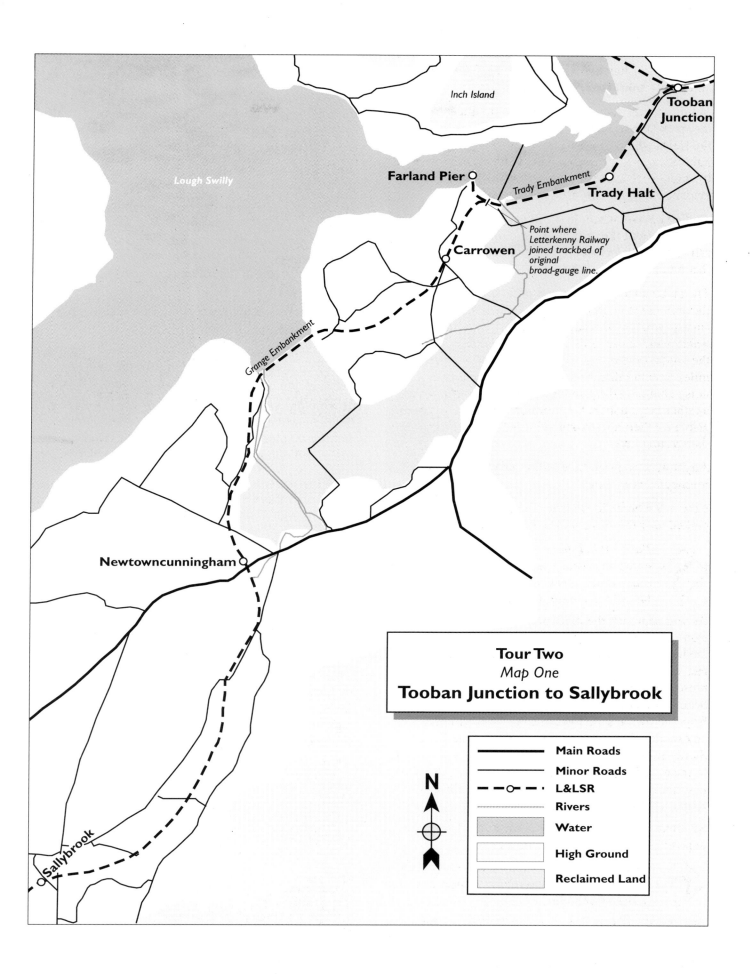

Inch Island

Lough Swilly

Farland Pier ○

Trady Embankment

Tooban Junction

Trady Halt ○

Carrowen

*Point where
Letterkenny Railway
joined trackbed of
original
broad-gauge line.*

Grange Embankment

Newtowncunningham ○

Tour Two
Map One
Tooban Junction to Sallybrook

N

────── **Main Roads**
───── **Minor Roads**
─ ○ ─ **L&LSR**
┄┄┄┄ **Rivers**
▓▓▓ **Water**
▭▭▭ **High Ground**
▒▒▒ **Reclaimed Land**

Sallybrook ○

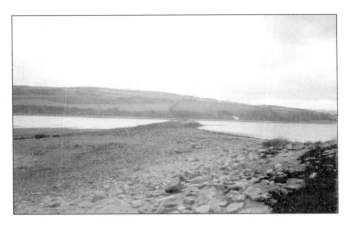

Top: The remains of the old pier at Farland Point, the original broad-gauge terminus of the L&LSR. *Above:* The embankment that carried the broad-gauge line down to the pier.

In broad-gauge days there was a pier at Farland Point served by steamers that called at many points up and down the Lough. A few stumps of the old pier still remain. This was the terminus for broad gauge trains connecting with the steamers but services were suspended in 1866 just a couple of years after opening, and the track was lifted in 1877. It had been found that the Buncrana "branch" from the Farland "main line" was much busier and more profitable and the steamers called at the branch's station and pier at Fahan.

However, in 1883, the Letterkenny railway opened its line from that town to Tooban Junction and utilised the old broad gauge trackbed for its new narrow gauge line. For a few years there was a change of gauge – and train – at Tooban until the whole Swilly system was united into the three foot gauge.

It's a constant job trying to keep these dykes around Inch Island in good order. At the time of our visit the Board of Works were effecting repairs by hauling large loads of rock across the Farland Embankment. One of the workers told us that the embankment was built about 140 years ago in the mid-1850s. He said that the original builders used donkeys and carts to haul the rock across. The tale is told that during the building of the dyke a donkey and loaded cart fell into the water at

the Inch Island end and neither were ever seen again, such being the depth of water and strength of current.

At this point where the Trady and Farland embankments meet you can make out where the old broad-gauge track's bed sloped down to and ran along the shoreline to Farland Point pier [333223].

The Letterkenny trackbed, however, swings around to the left (south-west).

We can actually drive along the old line but to do so we need to go back down the side of the embankment, turn right immediately and, within a matter of feet, you will find yourself driving along where steam engines once pounded.

You are now heading towards the first station out from Tooban: Carrowen Station.

This roadway along the old trackbed curves south-east through a deep earth cutting. Shortly, the road veers to the right and leaves the old railway's route.

Straight ahead you can see where the line carries on but the low embankment has been levelled into the fields although, at the far end of the field, you can see that it still remains.

Proceed around the two small corners to the left and then to the right.

On your left you can now see the low embankment running parallel with the road. Shortly, you will pass some houses where there stands the remains of an overbridge.

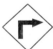

Turn right immediately after the bridge, towards Carrowen Station.

The trackbed now runs on your right, just beside the road on an embankment.

About 200 yards from the bridge you'll see Carrowen Station itself [327207], at the end of a short laneway, on your right. It's a small cottage but you should recognise it as a station by the traditional Swilly-style

Below: Carrowen Station, taken from a Derry-bound train on the 20th April, 1953. *H C Casserley*

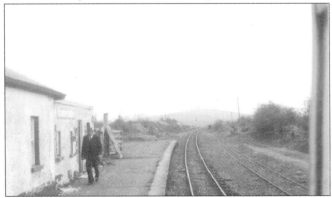

facia boards on the gable ends and a cut stone wall leading up the road into the station yard.

The weatherboards at the end of the gables are wide planks with several decorative holes cut in them at regular intervals.

All these old station buildings are now in private hands and usually occupied so, please, do not trespass or cause an obstruction.

Carrowen Station still has part of the original platform in place. It's visible on the right and left of the house extension to the rear of the station. The extension splits the old platform in half.

Some 200 yards past Carrowen Station we come to a crossroads. On the road to the right there once stood an overbridge of which very little now remains.

Drive through the crossroads [322205] heading directly south.

As you drive along you will see Castlehill on the right and that is just what it is: a castle – Burt Castle, in fact – on top of the only hill for miles around.

Below: Carrowen Station, from the road [328207]. ***Bottom:*** The remaining section of platform at Carrowen Station. The gate and timber pst (near the car) may well be an original railway one.

Above: Part of the underbridge arch at 314199. There's no arch on the other side as the field has been built up to the level of the bridge. ***Bottom:*** The overbridge at the Water's Edge end of the Grange Embankment, that is, the east end [310199].

Just ahead you will see a Y junction where there are several houses and a large shed or garage.

 Turn to the right and follow the road around Castlehill, passing two roads on the left.

 Take the third road to the left [314198] which leads down to the water's edge.

As you turn down the road you will see the arch of an underbridge on the right. However, on the other side of the road there is no evidence of a bridge at all as the field has been built up to the level of the old bridge there. So we have an underbridge on one side of the road and nothing at all on the other!

The track runs beside this road down to the Swilly river and then crosses the Grange Embankment [305195].

 Follow the road down to the water's edge, turn right and pass under a tall overbridge. Then turn immediately left and stop at the water's edge itself.

You can see that the railway ran over the tall overbridge then across the Grange Embankment to Drumboy on the other side of Blanket Nook. At the far end of Grange Embankment the track swings left towards Newtowncunningham Station.

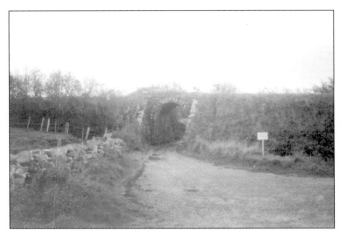

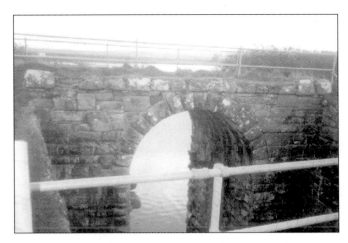

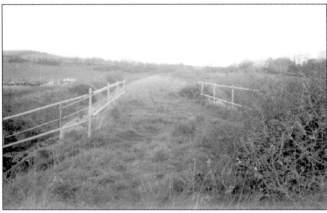

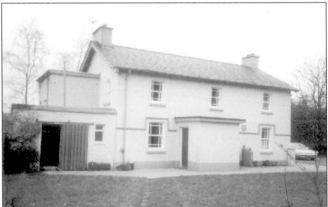

 Retrace your steps back to the Y junction. Bear right here and drive up to the main road (N13) once again.

You should come out by the Motorway Stores [334190].

 Turn right on the N13 towards Newtown and drive for two-and-a-half miles.

You'll by-pass Newtown village itself.

 Just at the far end of the village, turn right at the main road junction [305167].

The area you are now in is known as Moyle.

Drive down this road for about a fifth of a mile. You will see Newtowncunningham Station on your left opposite the school [300167].

By this time you should be experiencing no difficulty in recognising Lough Swilly Railway station buildings as they are all built to the same traditional design.

Just to the right of the station stands a water tower. It still has a wooden tank on top and it's more or less intact after all these years. To view the water tower drive just past the school and you'll see the tower on your left and, on your right, the remains of the overbridge and embankment on which the line ran across before entering Newtown Station.

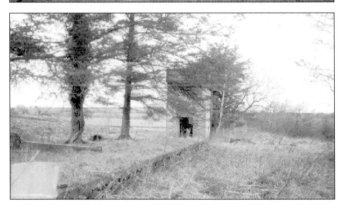

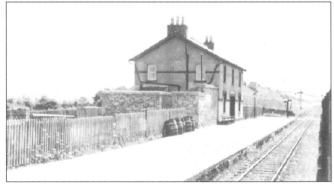

Top left: The overbridge at Grange Embankment. *Lower left:* The Embankment from the top of the bridge. *Top to bottom above:* **1** – The railway bridge at the flood gates (309199). **2** – Newtown Station house, note the original moulding around the ground-floor windows (299169). **3** – The water tower and platform at Newtown Station. **4** – The station in 1937, facing Burtonport. H C Casserley

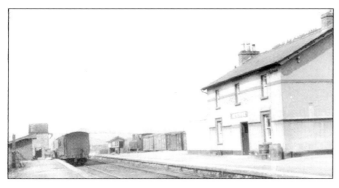

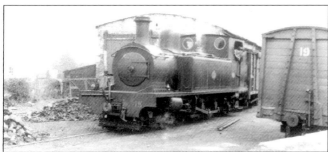

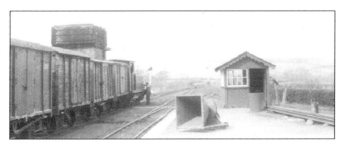

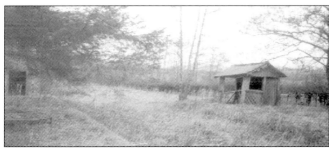

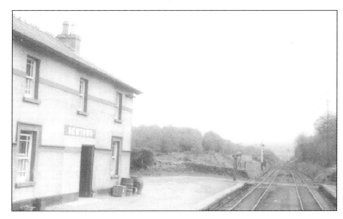

Top to bottom: **1** – Newtown Station, 1953. *H C Casserley*
2 – No 15 shunts the goods yard. *R M Casserley* **3** – And
then awaits the "off" for Derry. Note the signal box. *H C
Casserley* **4** – Newtown, 1995. The remains of the signal
box are on the right. **5** – A final 1953 view looking towards
Letterkenny. *H C Casserley*

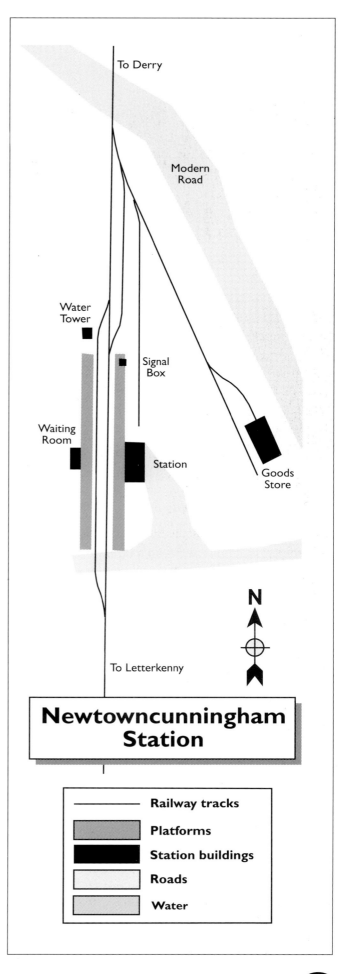

To Derry

Modern
Road

Water
Tower

Signal
Box

Waiting
Room

Station

Goods
Store

N

To Letterkenny

Newtowncunningham
Station

	Railway tracks
	Platforms
	Station buildings
	Roads
	Water

Left: The railway underbridge on the side road next to the main road, south of Newtowncunningham village (304155). Despite many changes the stonework appears in very fine condition.

To keep pace with the trackbed drive straight across the junction, bear to the left and immediately turn right past the Presbyterian Church. You are now heading south on yet another narrow road [304155] and this one is well used by articulated lorries and large tractors so be careful!

The railway embankment can be seen on the right and, about half-a-mile up this road, the track swings in from the right and runs very close to the roadside. At this point there is a small underbridge on a minor side road. We are now driving towards Sallybrook Station.

About three-quarters of a mile further on the road veers to the right and crosses the track on a cut stone bridge [298148]. The line is now on your left.

The bridge, of course, is long gone although some of the stonework on one side can be seen through the undergrowth.

If you have time you may wish to carry on down the road to pick up the trackbed at the other end of the Grange Embankment.

 To do this take the first road on the right just after the station.

 When you reach the T junction turn left. It's marked "Duffy Freight" to the right.

The line crosses under the road again and then runs parallel with the road down to the Drumboy end of the embankment. This is a popular spot for walking and many people take their Sunday afternoon stroll along this stretch of embankment.

The line cannot be seen now but it runs along the bottom of a short V-shaped valley to your left. There is an underbridge on a side road to the left about a mile distant from the T junction [296131]. This may help you to pinpoint the course of the line as it traverses the valley floor. However, the bridge itself is not worth a detour so proceed on this road in a south-westerly direction.

 Return to the main N13 road again and stop at the major junction.

The line crossed this main road a little way up on the right and continued on an embankment in a southerly direction.

After another three-quarters of a mile stop at the top of the hill and you'll see Sallybrook creamery and station house directly in front of you.

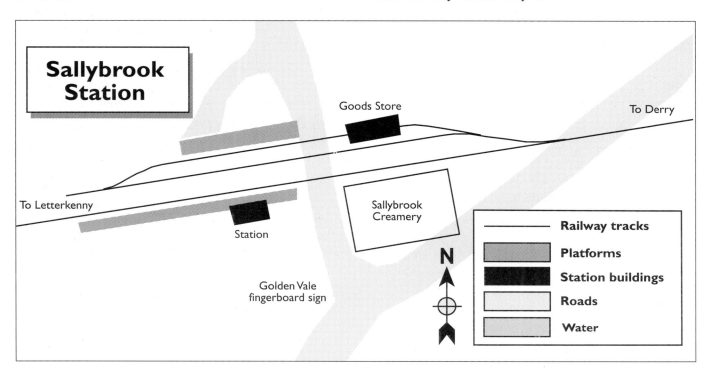

Sallybrook Station

To Derry

Goods Store

To Letterkenny

Station

Sallybrook Creamery

Golden Vale fingerboard sign

N

— Railway tracks
Platforms
Station buildings
Roads
Water

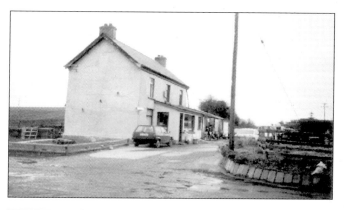

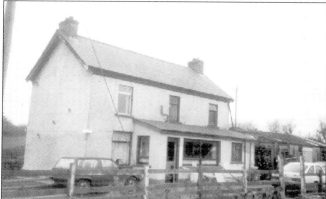

Both photos above: Sallybrook Station house. You have to look closely to see its railway heritage as the windows have been replaced and the mouldings removed.

 Drive down the hill until you meet the main road (well main-ish road, 276124) and turn left. This is a very long and very straight road leading due south.

Shortly you will see Sallybrook creamery (Lagan Foods) on the right. The line crossed the road here from left to right and ran in behind the creamery. Today nothing remains of the crossing, only a small piece of embankment is still standing but there must have been a bridge here at one stage.

 Just past the creamery turn to the right.

Look out for a finger board sign at the corner which reads "Golden Vale". Don't panic! We haven't suddenly been transported 300 miles southwards to Tipperary, you are still in Co. Donegal unless, of course, you're reading a different map!

This little road runs alongside the creamery to the station house opposite on the left. The line originally ran behind the creamery and then along to the station platform which was at right angles to the road. There are no platforms, level crossings or sidings left to see today.

 Return to the Golden Vale sign on the main road and turn right [275117].

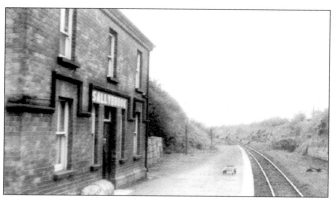

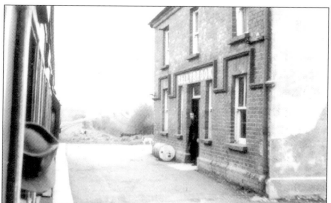

Both photos above: Two views of Sallybrook facing, respectively, towards Letterkenny and towards Derry. Taken from train on the 20th April, 1953. *H C Casserley*

The trackbed is now on the right, and right out of sight.

 Drive for a mile and turn right at the Galdonagh crossroads [275099].

You'll see that it's signposted *St Johnston 6 miles, Manorcunningham 2fi,* and that's our next port of call: Manorcunningham Station, commonly known as Manor Station.

Drive along for about another mile until you reach the school at Drumoghill, avoid any turn offs. Stop just past the school, there is a road to the right [257101].

There's a blue traffic sign here reading "Danger, please drive slowly", but note that it is, in fact, facing away from your direction of travel.

This is the exact spot where the line crossed the road on a bridge. The bridge itself no longer exists but immediately beside the site of it there is another bridge, still intact, which spans a small river, although it is well camouflaged with ivy so you need to keep your eyes peeled.

After this bridge you can see that the line continued on a high embankment towards Manor Station.

Proceed along the road in a westerly direction.

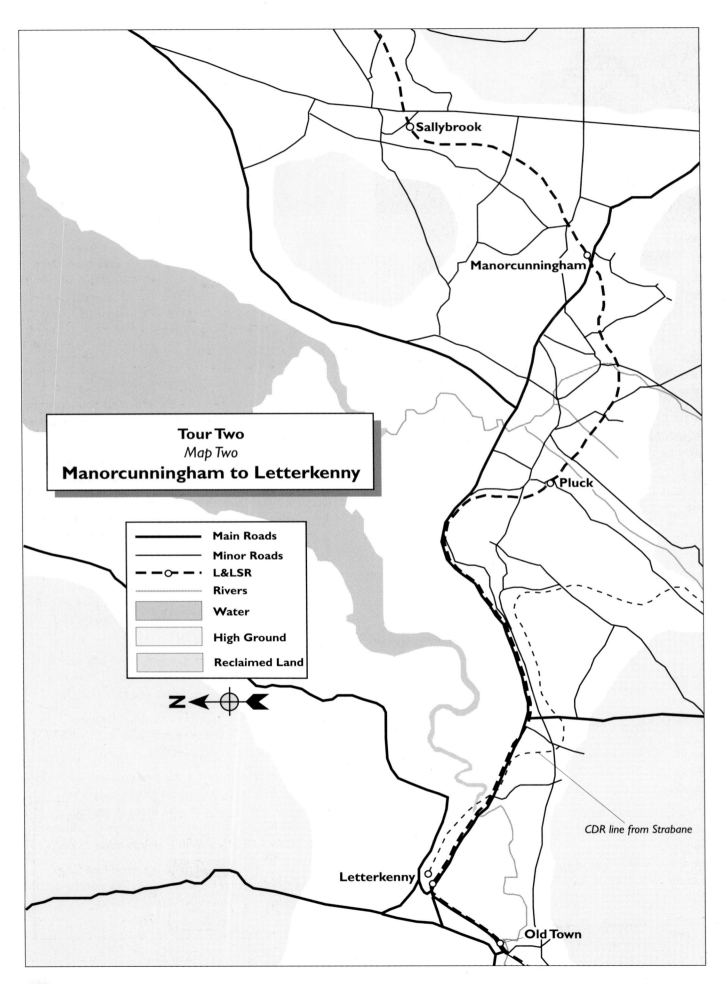

Tour Two
Map Two
Manorcunningham to Letterkenny

Sallybrook

Manorcunningham

Pluck

	Main Roads
	Minor Roads
	L&LSR
	Rivers
	Water
	High Ground
	Reclaimed Land

CDR line from Strabane

Letterkenny

Old Town

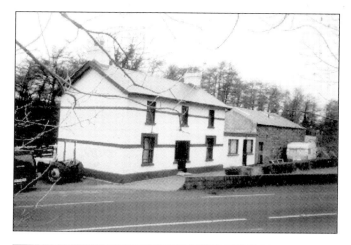

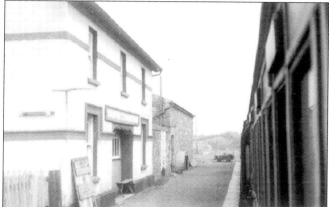

Top: Manorcunningham Station, complete with original mouldings and windows well maintained. *Above:* The station as it appeared in 1953 when photographed from a passing trainheading for Derry. Note the original platform entrance in the centre of the station house. *H C Casserley*

From the hills to the Dry Arch
Manorcunningham to Letterkenny

You can follow the embankment on your left and shortly you'll see Manor station house in the distance.

 Very quickly you'll emerge onto the Letterkenny to Strabane main road, the N14. Turn left back along the main road (N14) and drive up to Manor Station at the top of the hill [254098].

In true Swilly style Manor Station was situated two-and-a-half miles from the village it served!

The station itself is well preserved with a fine cut-stone goods store at the rear end. The present occupier told us that the station was in a state of disrepair when she first moved in and that wooden lettering from the original Manorcunningham station signboard was found strewn about the garden. It's very sad to hear of such disregard for our railway heritage – but attitudes are changing!

 Retrace your steps along the main road down the hill towards Letterkenny and, on a sweeping left-hand bend, take the first minor road on the left at the "Stop" sign.

Drive south west past the school [245101] on the sharp corner and on up the hill.

You are driving towards Labbadish with the old railway line on your left. Within a quarter-of-a-mile you reach the T junction at Labbadish [239097].

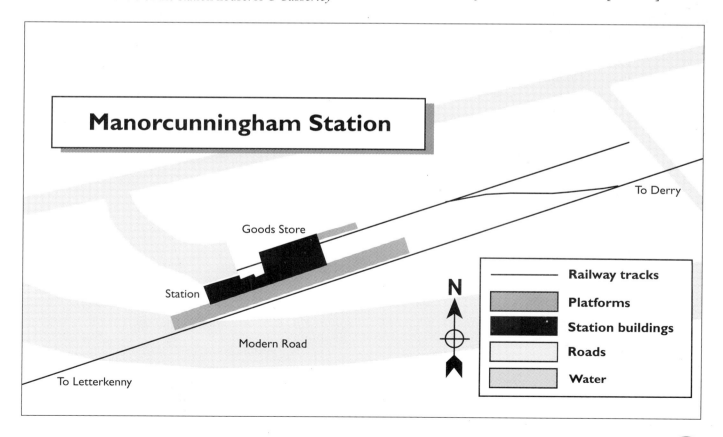

Manorcunningham Station

Goods Store

Station

Modern Road

To Derry

To Letterkenny

N

——— Railway tracks

Platforms

Station buildings

Roads

Water

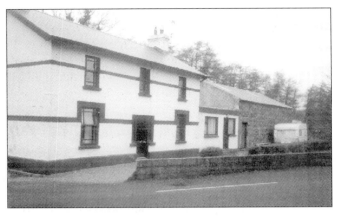

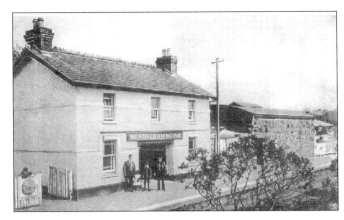

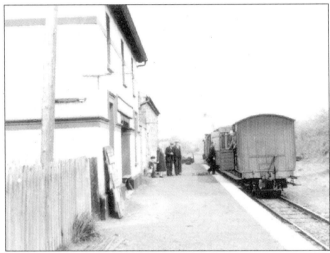

Above: Manor Station today. ***Top right:*** Manor Station – an early postcard view. ***Right:*** Another view of the station taken in 1953. You can almost hear the engine quietly ticking over. *H C Casserley* ***Below left:*** The overbridge just south of Pluck village (233096). ***Below right:*** Pluck Station house, much modernised.

In front, you will see the red-bricked chimney stacks of the old Labbadish alcohol factory, now disused and in a run-down state.

 Turn left and then bear right over the stone bridge besides the factory [239097].

The trackbed crosses several minor roads off to the left but there are not enough remains to warrant a detour to view what's still there. This area is known as Corkey and the bridge you have just crossed over spans the Corkey River.

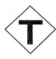 *Go along for another quarter-of-a-mile to the larger road, past some workers' cottages on the right. At the T junction turn left towards Letterkenny.*

This was the original Derry to Letterkenny main road which was replaced by the new road, the dual carriageway N14, which runs away over on your right. The railway line is on your left and is heading for Pluck Station. The village of Pluck lies about another quarter mile from the T junction.

There is a small side road to the left just before entering Pluck and you could make a slight detour up this road to inspect the old railway bridge which is intact and in good condition [233096]. The bridge is about half-a-mile up this side road.

 Meanwhile, proceed north west through Pluck village and then take the first road on the left, after the Rossbracken bar [225106]. Follow the road for another quarter-of-a-mile to Pluck Station itself.

As you round a left-hand corner you will see a white house. This is Pluck Station [225103].

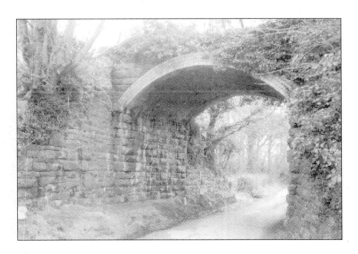

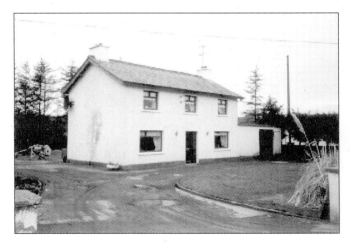

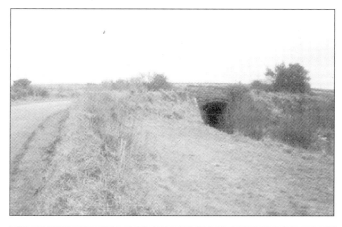

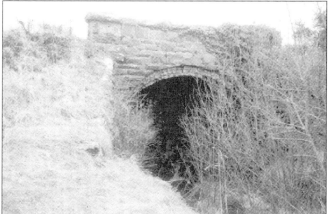

Both above: The overbridge just beside Pluck Station [224104].

The road continues and doubles back over a cut-stone bridge just to the left of the station. This building is not recognisable now as a Swilly station house. However, between the station and the overbridge there is a strip of raised ground which may have been part of the platform.

 Retrace your steps back to the old main road and turn left.

The road then bears to the right on a sweeping bend and runs parallel to the new dual carriageway with only a fence dividing us from the main road.

 Turn right onto the dual carriageway, heading west towards Letterkenny.

You are once more driving along on the old Swilly trackbed. The dual carriageway was built right on top of the railway's route and we shall follow it to the Dry Arch Roundabout at Letterkenny (195106).

Stop near the roundabout.

At this point the line used to run along an embankment and over a cut stone bridge which was located just where the roundabout is today. This bridge was known locally as the Dry Arch. We don't know the origins of the name so we can only assume that people

sheltered there from the rain and remained dry under the arch/bridge. When the Dry Arch bridge was demolished during the construction of the road and roundabout many people were upset by the removal of this famous local landmark. At least its memory is kept alive in the name of the traffic junction!

Drive across the roundabout and along the flat straight road towards Letterkenny.

The track ran parallel to this road, behind the Clanree Hotel. Just past the hotel, on the right, you will see Murphy's Plumbing and Plant Hire and, directly opposite Murphy's, there is a small road on your left.

Pull in and park just past the little road – it's time to do a bit of walking but don't worry it's only a few yards.

Walk up this small road for a few yards and on the first bend you'll be able to note the point where the Swilly ran across the road at right angles and then immediately dived into a steep and narrow cutting to the right. A bungalow has been built in the mouth of the cutting right on the well-constructed base of the old railway line.

Past the house and in the distance you should be able to see the remains of a bridge. This was the point where the Lough Swilly Railway line from Derry to Letterkenny was crossed by the County Donegal Railway from Strabane [191108].

The CDR came in from the left, crossed the bridge and then ran parallel with the Swilly's metals into Letterkenny itself. Now if you look again to the left of the bungalow in the cutting you'll see a white CDR crossing keeper's house. Here stood Baird's crossing gates, the last gates on the CDR line before the terminus. This is also the homestead of our very own artist John Baird.

Below:
The L&LSR railway cutting near Letterkenny. The abutments of the overbridge that carried the County Donegal Railway over the Swilly can just be made out in the distance (191108).

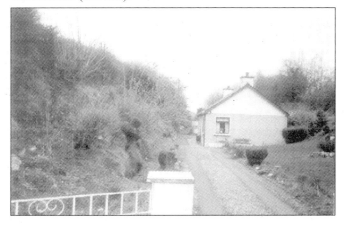

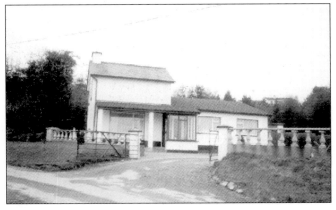

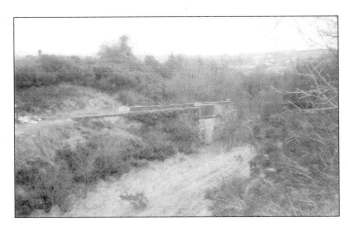

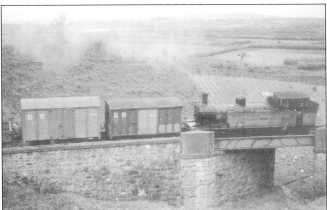

Now return to your car, feeling suitably refreshed after your short stroll, and continue on towards Letterkenny town.

Both railway lines emerged from the cutting to your left and ran very close together with the embankment on your left, next to the road, carrying the CDR line alongside and above the Swilly line. The Swilly's trackbed is just out of sight on the other side.

Look for the Shell filling station on your left.

There is a small side road behind the filling station which runs over two bridges, carrying the road over both railway lines. The Swilly used a single arch overbridge here while, conversely, the CDR used a three-arched bridge: two smaller arches either side of the main arch.

Top to bottom left: **1** – Baird's crossing gates house. **2** and **3** – The abutment of the CDR overbridge. **4** – The L&LSR and CDR trackbeds running parallel towards Letterkenny in the distance (181107). *Top to bottom right:* **1** – The CDR overbridge crossing the Swilly trackbed today. **2** – And as it appeared in the days of steam. *J G Dewing* **3** – The Swilly underbridge behind the Shell filling station (185110).

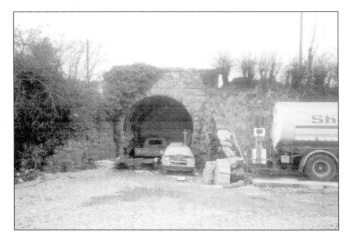

The present owner of the filling station has made good use of the CDR bridge by bricking up one side and building a garage against the other. In effect he now has a garage with three bays, the roof of which is actually the side road. It's worth seeking permission to view this unusual structure.

Drive on towards Letterkenny.

At exactly one mile on from the Dry Arch roundabout you will cross the Port Bridge [184113] over the River Swilly. There's no evidence of the railways at this point but originally the two lines ran through the site of what is now the Bord Failté offices then crossed the river again on two stone bridges and immediately swung right across the main road on two more bridges.

Stop just after Port Bridge and look to the left of the advertising hoarding besides Charles Kelly Ltd's warehouse.

You can see the remains of the two bridges plus part of the embankment. Behind the hoarding you can see where a CDR siding ran down in front of Kellys and on to the quay at the port. The crossing gate here was recently restored by members of the CDRRS and there are several interesting murals by John Baird on the warehouse wall, including one of a CDR loco and train.

Continue on this wide road into Letterkenny.

The railway lines ran on the right-hand side of the road and behind what is now the Regional Technical College into the two stations at Letterkenny. These were located at the appropriately named Station Roundabout.

Today, nothing remains of the Lough Swilly Railway station, the site has been completely built over by the shopping centre. However, the CDR station building and goods store remain, the former being now used as the town's bus station. If you had travelled into Letterkenny on the CDR line from Strabane this was now the end of your journey but if you had come up from Derry on the Swilly route that we have just finished tracing then you could well have travelled onwards by train, through the town and out into the wild and mountainous landscape of north-west Donegal to the far-off fishing village of Burtonport.

Letterkenny can still conjure up the atmosphere of travel to remote and picturesque parts. The coaches of Bus Éireann still follow the old CDR route to Strabane and connect with that railway's headquarters at Stranorlar before heading onwards to south and west Donegal. CIÉ follows in the CDR tracks because it is the commercial successor to that old narrow-gauge network.

But for a real taste of the Lough Swilly you can do no

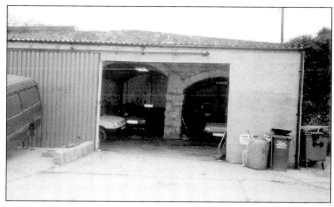

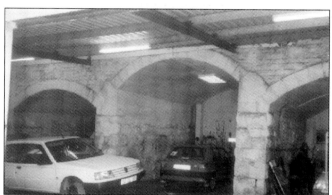

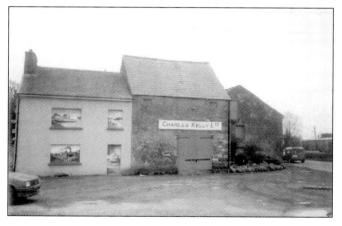

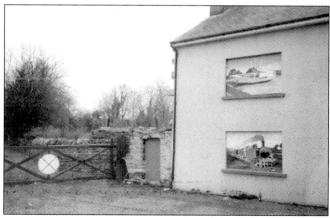

Top to bottom: **1** – CDR underbridge behind the Shell filling station. **2** – A closer view of the underbridge. **3** – Kelly's at Port bridge. Note the fine murals by John Baird (184113). **4** – The railway crossing gate restored to its original condition by CDRRS members at Port Bridge, Letterkenny

better than to catch the service of the Londonderry and Lough Swilly Railway Company itself. OK, they may have traded in their steam engines and railway lines for buses and tarmacadam but you can still travel along the trains' routes to Kilmacrennan, Creeslough, Dunfanaghy, Gweedore and beyond and see plenty of evidence of the LSR's Letterkenny and Burtonport Extension Railway 90-plus miles of routeways.

But that, of course, is another story, or rather two more stories, as we've divided up our survey of that line into two full-day tours.

So, pause for a moment at what was really the heart and soul of the Londonderry and Lough Swilly Railway: Letterkenny Station; and try and imagine the daily scene when both stations were busy with passengers and freight, steam trains puffing, diesel railcars chugging along, goods of all sorts being loaded and unloaded, people making their way hither and yon – all part of Donegal's wonderful railway heritage.

PS. We couldn't really finish this part of our survey without mentioning the County Museum, High Street, Letterkenny. Park the car and walk up to the main street, then double back at the traffic lights (allegedly the only set in Co. Donegal!) and continue uphill for about 100 yards. The museum is on the left. It's well worth a visit and contains a good selection of railway memorabilia. The curator and staff have done much to help publicise the railways of Donegal and the CDRRS is very proud to be associated with their efforts.

The museum is open on Tuesdays to Fridays from 11.00am to 4.30pm and on Saturdays from 1.00pm to 4.30pm. It's closed on Sundays and Mondays. You can phone for further information and details of special displays on 074 24613 or fax on 074 26402.

Top: The remains of the County Donegal Railway overbridge at Port, near Letterkenny, now almost entirely overgrown by the shrubbery.
Above: The remains of both L&LSR and CDR overbridges at Port (184113).
Below: A general view of Letterkenny Station with no. 15 about to depart to Derry with the 2.15pm mixed train. The goods store is on the left. Note the derelict carriages used as stores on the right, by the station house.
R M Casserley

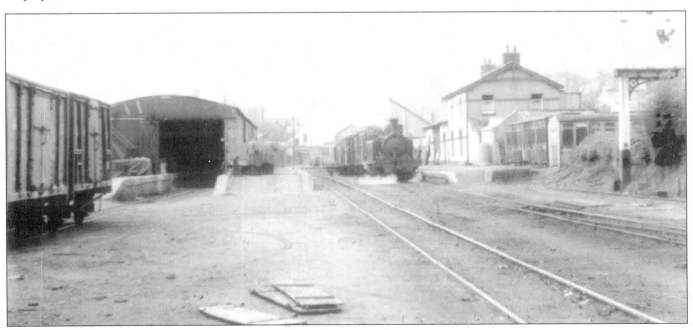

The Lough Swilly Railway Timetable for 1926

We reprint below an extensive extract from a timetable issued by the Lough Swilly Railway on the 21st June, 1926. The actual train details only occupied two pages but the timetable booklet ran to over fifty!

By this date railway timetables, especially those of the smaller companies, had becoming important advertising items and usually included an extensive description of the countryside through which the lines ran as well as paid adverts from local hotels and other businesses. They are always well worth reading, if only for the insight they give to the attitudes and expectations of the day.

This example from the Swilly appears to be mainly aimed at the "huntin', shootin' and fishin'" fraternity although there is good coverage for golf: a pastime that was then rapidly growing in popularity. While many of the attractions remain so to this day, it's interesting to see that changing fashions – and attitudes – no longer regard seal-shooting at Burtonport or blasting sea birds at Horn Head (surely now a sanctuary) as an essential part of any holiday in Donegal! It's perhaps a bigger indication of just how much times have changed in that the "scenery tourist" appears to be only catered for in passing and that there is no mention of the wonderful atmosphere of welcome, friendship and tranquility that pervades almost every visitor's experience of County Donegal.

" **ChurchHill**, the station for Gartan Lakes, Glenveagh Castle, the upper water of the Lennon River, etc. GARTAN is a charming and interesting neighbourhood, celebrated as the birthplace of St. Columba, AD 521. … As a rule the fish do not run Gartan Lough in any number until the latter part of the season. It is a capital brown-trout lough from May onward; baskets of four or five dozen fish, averaging three to the pound, constitute a fair day's sport. Close by are two other smaller loughs, both of which provide good trout fishing. The fishing is free, and Safe Boats are provided for lake fishing at a nominal charge of 2/6 per day. There is comfortable hotel accommodation at Gartan and in Churchill. GLENVEAGH CASTLE is one of the "show places of County Donegal"; and very beautiful it is. "If my glen and my lake were not Irish", wrote the Rev. C. Otway, eighty years ago, "if the curse of being out of fashion did not put everything Irish under attainder, I would encourage my mountain nymph to hold herself as fair in varied beauty as any of them." No tour of Donegal can be considered anything like complete unless a visit be paid to Glenveagh Castle.

THE RIVER LENNON has its source in Gartan Lough, and flows in about fifteen miles into Lough Swilly at Ramelton. The fishing on the whole of the river is now free; and it is one of the best free salmon rivers in Ireland. It is conveniently fished from Churchhill, Kilmacrenan, Milford and Ramelton. There is comfortable hotel accommodation in all four centres. The course of the Lennon is sinuous, and in some parts it is sluggish; in others there are some strong streams and broad, deep pools, alternated with boulder-strewn flats and gravelley shallows. It is not at all a difficult river to fish; in fact the greater part is easily covered from the banks with the assistance of a fourteen or fifteen foot rod. Leaving Churchhill, a little further on is **KILMACRENAN**.

Here St Columba was educated at the MONASTERY, remains of which are still to be seen. Not far from the station is the famous DOON WELL, the waters of which were blessed by Lector O'Friel. During certain seasons of the year the well is the scene of a pilgrimage for hundreds of people seeking benefit from its reputed miraculous power of healing various diseases. Near the well is the Rock of Doon, where the chiefs of Tyrconnell, the O'Donnells, were crowned. In addition to the River Lennon there is capital fishing in several loughs and small streams in the neighbourhood of Kilmacrenan and Milford, which is within four miles. The chief loughs are LOUGH FERN and LOUGH KEEL. The former is a very fine sheet of water, three miles long, and offers – as a free water – exceptional facilities for the salmon and trout fisher. Taylor's Hotel at Kilmacrenan has boats on this lough and Lough Keel, which is a good brown-trout water. Leaving Kilmacrenan, the railway passes through BARNES GAP, a wild defile indeed, and emerging from this the train crosses the OWENCARROW VIADUCT, an engineering work of some importance, 380 yards long and 40 feet high. From the Viaduct a fine view of Errigal and Muckish, the two highest mountains in Co. Donegal, is obtained. Looking up the valley of the Owencarrow a glimpse is obtained of Glenveagh Castle hemmed in by the proud heights of DOOISH (2,147 ft.), ALTACHOASTIA (1,737 ft.), KEANMACALLY (1,220 ft.), and KINGARROW (1,068 ft.). The OWENCARROW, over which the Viaduct passes, is a capital salmon river, and is fished by guests at Rosapenna Hotel. Looking down from the valley, the beetling side of LOUGH SALT MOUNTAIN (1,546 ft.), forms a prominent feature in the wild landscape of its surroundings.

Just beyond the Viaduct is **CREESLOUGH** in the neighbourhood of which are some capital brown-trout loughs, and from July onward sea-trout run into the streams emptying into Sheephaven Bay close by. At the foot of a steep hill just out of the village and on the road to Rosapenna, is DUNTALLY BRIDGE and WATERFALL; the fall is well worth a visit, it lies a few yeards off the main road. Creeslough stands on an eminence commanding a very fine view of the country. There are two good hotels available. This is the station for **ROSAPENNA HOTEL.** Cars run (by appointment) Daily (Sundays excepted) between the Station and the Hotel.

It is a very interesting drive from the station to the hotel. The first object of interest *en route*, and a prominent one in the district, is DOE CASTLE, which should certainly be visited by the tourist. It was originally the stronghold of the M'Swyne-na-Doe, and in the past has been the scene of much bloodshed and intrigue; it is now the property of the Stewart family, of Ards. A little further on is LACKAGH BRIDGE, and the famous salmon and sea-trout river – THE LACKAGH , if caught in proper ply, is a sure catch for a salmon or two, there is only about a mile-and-a-half of water, but most of it is useful to the salmon angler; it is not necessary to wade this river. The Lackagh has its source in GLEN LOUGH, probably the best sea-trout lough in the north of Ireland; it is also a good salmon water, and the fishing on it is reserved for guests at Rosapenna Hotel. Glen Lough is a lovely sheet of water over two miles long and about half-a-mile average width. It is set amidst delightful scenery and sheltered by mountains on all sides. Passing through the village of CARRIGART we reach Rosapenna, the most important, largest, and best-equipped hotel in the north-west. It was erected by the late Earl of Leitrim in 1893, and, each year, has been increased in size until at the present time it provides accommodation for 100 guests. It is so well known as a sporting and touring establishment as to need no comment. Situated in a most picturesque part, midway between MULROY BAY and SHEEP HAVEN, it has the advantage of a bracing yet sheltered position, and is quite an ideal spot for a holiday. Pleasure and recreation of the highest order are here, including angling, boating, bathing, mountaineering and golf.

The GOLF LINKS at ROSAPENNA encircle the hotel. They were practically discovered by the well-known Tom Morris, of St. Andrew's, in 1893, but it was not until the Spring of 1906 that, on the advice of Harry Vardon, the course reached championship dignity. Mr. Vardon states that "Rosapenna Links can now take rank with the best championship course in the United Kingdom (*sic*). It would be difficult, if not impossible to find country better suited for golf than that around Rosapenna. There are fine natural hazards, the turf is good, and the scenery delightful." It is an eighteen-hole course (6,000 yards), and all the greens are natural. The first tee and that for the last hole are close to the hotel. There is no cross play.

There is good sea-trout fishing in Mulroy Bay, close by. Throughout the whole district there is good shooting for

grouse, woodcock, snipe, duck, geese, hares and rabbits. There are miles and miles of shore-shooting of excellent quality. Mulroy Bay, "The Norway of Ireland," is an exceedingly lovely place; it is doubtful if there is its peer in all Ireland. Due north of Rosapenna is the peninsula of ROSGUILL, a most interesting study for the geologist, the antiquarian, and the naturalist. From the top of GANIAMORE MOUNTAIN (958 ft.) a very fine view of the surrounding country is obtained. Other places and objects of interest are: the Church, cross and "circle-inscribed" rock surfaces at MEVAGH; the sand dunes; the circular stone forts; "THE EYE" OF ROSGUILL; and the important herring fishing station at Downings across an arm of the Bay.

CARRIGART – stated to be the cleanest village in Ireland – is fortunate in possessing a splendid hoel – Friel's – whose guests have permission to play on the Rosapenna Links, which are close by.

Continuing the journey from Creeslough about a mile further ahead is DUNFANAGHY ROAD STATION, which is four miles by car – a lovely drive – from bright, breezy, and bracing **DUNFANAGHY**, a rapidly rising tourist resort, situated on an important and beautiful arm of Sheephaven Bay. Cars meet all trains at the station.

At Dunfanaghy there is an eighteen-hole Golf course, three

miles in extent, which skirts the picturesque Dunfanaghy Bay, and the scenery around is charming in the extreme. At the first tee the player is confronted by a stretch of rocky beach., and a bad drive is disastrous; the green, however, is easily reached by a straight ball followed by a mashie shot. The third green is guarded by a tortuous stream, and requires a good drive and a straight brassy shot to reach it. The fourth hole presents no particular difficulty until the green is reached, when care must be taken lest the approach overruns the green and lands in a ditch. At the sixth tee a drive of one hundred and thirty yards is necessary to negotiate safely the second stream; a short ball here may land among sand bunkers. The seventh hole is approached over a stretch of marshy land, but a straight drive from the tee will find the green. A moderate drive or iron shot reaches the eighth green, and the ninth hole is also a short one. The tenth hole runs parallel with the sea and is perilously near a rock-bound part of the shore; the approach shot requires careful calculation, otherwise the ball may overrun the sloping green and land in a deep sandy bay below. This hole *may* be obtained in four. At the eleventh tee the drive is over a stretch of sandy beach. At this point of the round a very charming view is obtained of the picturesque surroundings of these links. Beneath one's feet the sea breaks against the warm coloured rocks; immediately ahead is the slope of a sandy strand, and piled up inland are the hills, while in the distance, across the bay, loom the rugged heights of the peninsula of Horn Head. The golfer however may well be careful about his drive, for a topped or short ball will surely land in the bay a clear drive of at least one hundred yards being required to escape penalty. In front of the twelfth tee extends a huge sand bunker, and just beyond this is a low stone fence. Number thirteen is the longest hole in the course, and requires four shots to reach the green, a stream being crossed on the way. At number eighteen the drive from the tee is over the face of a hill honeycombed with rabbit holes, and the brassy shot must be straight and true to avoid getting on the shore. Altogether the golfer will find on these links an abundant variety of play, and fine scope for long hard hitting. Convenient shelters for Golfers have been provided on the Links.

Dunfanaghy is the nearest centre for exploring HORN HEAD, THE MARBLE ARCH, "M'SWYNE'S GUN" and the beautiful MARBLE HILL STRAND. Horn Head is, perhaps, the most impressive of the north Donegal cliffs; it rises sheer from the sea to a height of 625 ft. and the view from the top is very fine. There is good trout fishing in RUNCLEAVIN LOUGH, PORT LOUGH and SESIAGH LOUGH, within two miles of Dunfanaghy; and some sea-trout can be caught in the Bay. Horn Head is the home of thousands of sea-birds and wild-fowl congregate during the winter in great numbers, affording excellent sport for the shooter. There is comfortable hotel accommodation and private apartments in the village, and at PORT-NA-BLAGH, a first-class Hotel has been lately erected.

Dunfanaghy is also convenient for visiting **TORY ISLAND**, the "sentinel of the Atlantic", the cliffs on the east side of which are very grand and wild. On the island is one of the most important lighthouses on the northern coast; and here is also LLOYD'S SIGNAL STATION. On Tory Island life is experienced under primitive conditions of living: here are no rats, cats, police-stations, or pawn-offices: the inhabitants pay neither rent, rates nor taxes; and depend for an existence almost entirely upon fishing and kelp-burning. The gunboat "*Wasp*" was wrecked on Tory, September 22nd, 1884, and all but six hands lost. There is excellent sea-fishing to be had in the waters around Tory; but it is difficult at times to land on or leave the island and dangerous in rough weather.

Returning to the railway; from Dunfanaghy Road the next station is **FALCARRAGH**, which is also convenient for visiting Tory Island, and is the nearest place from which to climb MUCKISH MOUNTAIN (2, 197 ft.). It is a stiff but by no means dangerous climb, on top there will be found quite safe footing, although from below the summit appears to be jagged. As a matter of fact a small plateau enables one to stroll around and admire the wonderful panorama spread out for miles and miles below. With the exception, perhaps, of the view from the summit of Errigal, there is nothing to excel it in all Donegal. In Ray old churchyard there is an ancient CROSS hewn from a single stone, 22 feet long, supposed to have been carried there by St. Columba; and in the grounds of Ballyconnell

51

House is the stone of CLOGHANEELY, said to be the block on which "Balor of the mighty blows", the famous one-eyed giant of Tory Island, beheaded MacKineely, another famous chieftain. The correct name of the stone is Cloch-chinn-fhail-aidh, "the stone of Kinfaila". In addition to climbing Muckish, the mountaineer will find occupation in surmounting the heights of CROCKNABARAGH (1,554 ft.) and several less important peaks. An interesting excursion, by car, is to the desolate district of BLOODY FORELAND. There is good fishing for salmon, sea-trout, and brown-trout, in several rivers in the district, the chief of which are the TULLAGHOBEGLY, the RAY, and the GLENNA. There is comfortable hotel accommodation in the village.

Continuing the journey by rail, the next station is **CASHELNGORE**, and here there is capital brown-trout fishing in several loughs. This is the station from which to reach ALTON LOUGH and AGHLA MORE MOUNTAIN, which rises sheer from the lough to a height of 1,800 feet: it is not too much to say that the surroundings of Alton Lough constitute a sublime composition of wild, grand scenery. It is about a mile from the station to the lough. This is also the station for Cloughaneely Irish College, which large numbers of students attend during the Summer months. The nearest hotel accommodation is at Gortahork and Falcarragh.

Once more resuming our journey by rail we reach the important touring and sporting centre, **GWEEDORE**, and here there is an excellent hotel, admirably conducted. It is the pioneer establishment in Co. Donegal, charmingly situated on the banks of the Clady River, and close by the King of Donegal mountains, Errigal. As a touring centre pure and simple, this would be hard to beat, and the Manager of the hotel puts some really good cars at the disposal of his guests; with the help of them and a good sturdy pair of legs some exceptionally fine scenery can be revelled in. The popular excursion is to THE POISONED GLEN, DUNLEWY, and the summit of ERRIGAL (2,466 ft.), the highest mountain in Co. Donegal, and the second highest in Ulster, its peer being Slieve Donard, in Co. Down. The ascent is by no means difficult, although somewhat fatiguing; the view from the top, on a fine day, is extremely grand. Under favourable conditions one can see Knock Layde at Ballycastle, Co. Antrim, and Ben Bulbin, near Sligo; also Bengore Head and the Paps of Jura. Errigal itself can be seen from within a mile of Omagh, Co. Tyrone.

The poisoned Glen is a dark, awesome defile terminating in a frowning range of battlemented precipices; a wild spot indeed, and one that deservedly ranks among the chief "show places" of the North of Ireland. In marvellous and most beautiful contrast DUNLEWY LOUGH, DUNLEWY HOUSE, and the charming grounds surrounding them lie nestling in the shelter of the valley below. Other excursions are to ALTON LOUGH and to TIEVELAHID MOUNTAIN (1,413 ft.). DERRYBEG and BUNBEG are about three miles distant on the sea coast. MIDDLETOWN is situated between the two. Here Mr M'Bride has established a hosiery factory. Knitted wear of finest designs are manufactured. BLOODY FORELAND can also be visited from here.

Excellent centre as it is for the holiday tourist, Gweedore more especially appeals to the visitor as an important angling headquarters: there is no better in all Donegal. The fishing is for salmon, sea-trout, and brown-trout, all of exceptionally good quality. The waters available are – LOUGH NACUNG, THE CLADY RIVER, THE CROLLY RIVER, LOUGH ANURE, and several smaller rivers and loughs. As a salmon river the Clady is too well known to need comment. There is no charge to guests at the hotel for fishing the Clady, or for fishing the loughs and other rivers. Fish caught may be retained on payment of the market price.

The Crolly River and Lough Anure are fished on the same terms as those in force at the Rosses Fishery, which is presently referred to. The next station to Gweedore is CROLLY, and here there is a comfortable sporting hotel, and the proprietor has the right for his guests to fish in the Crolly River, Lough Anure, and several small loughs in the district. A carpet factory has been established here by Messrs. Morton & Co., Darvel, employing a large number of hands.

Resuming our journey by rail, passing the next station, KINCASSLAGH ROAD, we reach DUNGLOE, which is the place

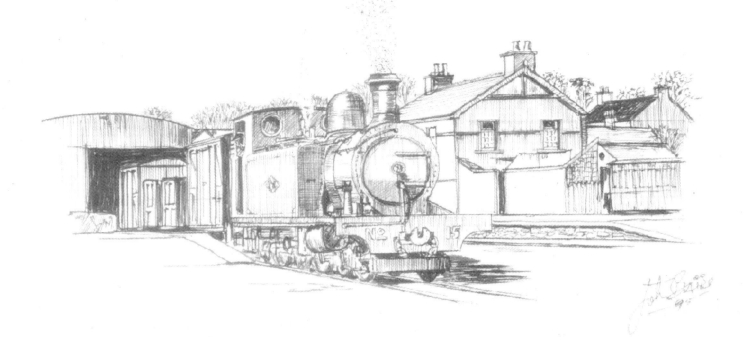

to alight for the famous **ROSSES FISHERY**.

The Rosses proper includes nearly sixty-thousand acres of land, one-hundred and twenty-seven loughs, and over fifty fishable miles of rivers, all of which provide sport of more or less excellence with salmon, sea-trout, and brown trout. This is another of the Donegal fisheries that is so well known as to need little or no comment here. Mr. J. F. O'Donnell of Burtonport, the Manager of the fishery, will send all particulars to those who intend paying the district a visit. There is plenty of hotel accommodation in the village. The charges for fishing are: from the 1st of March until the 30th of June, 10/- per week, from the 1st July until the 31st of October, 25/- per week, or 60/- per month. No charge is made for anglers staying in Sweeney's or O'Donnell's Hotels. There are boats on the principal loughs for which no charge is made, but the boatman's fee is 5/- per day and refreshments. As a rule two anglers fish from one boat. Much of the fishing occurs within easy walking distance, but to reach some necessitates the use of a car, which is also generally shared by other anglers proceeding in the same direction. Thus the fishing at the Rosses is not at all expensive. the arrangement for fishing the various loughs is as follows:- A printed plan is kept in Mr. O'Donnell's office, and each evening the holders of fishing tickets for the morrow are lotted out certain waters, and this allotment is so arranged that each angler has the opportunity of fishing each of the best loughs in turn, should his stay be sufficiently long for him to do so. Cards are sent overnight to the anglers wheresoever they may be staying, and on these appear the name of the water to which the holder is entitled. Of course it is open to anglers to exchange waters among themselves, and this is frequently done. The most popular of the loughs are:

DUNGLOE, MEENLECKNALORE, TULLY, ANURE, ILLION, ALECK MORE and MEELA. The chief rivers are: the DERRYDRUEL and the CROLLY. There is good sea-fishing and wild-fowling in DUNGLOE LOUGH. The district is essentially an angling one, but there are a few places of interest to the ordinary holiday tourist. The chief of these are: CROAGHY HEAD, which should certainly be visited, MAGHERY BAY, where there is a delightful strand, and a remarkable landslip known as THOLLA BRISTHA i.e., "Broken earth".

From Dungloe Station the terminus of the railway is quickly reached; this is **BURTONPORT**, a fishing centre, with a well-sheltered harbour, protected from the winter storms by the island of ARRAN, and several others. These islands can be easily reached and afford opportunity for health-promoting and most enjoyable ramble. The island of Arran, or Arranmore, is the largest; its cliffs and caves are very fine, and should be seen by all tourists in this direction. This is an important centre of the Donegal herring fishing industry, and in the season enormous takes of fish occur, as much as £15,000 value of herrings having been taken in a season. The scene during the herring season is most interesting. Burtonport is in the Rosses fishery area and several of the loughs are advantageously fished from it; in addition there is excellent sea-fishing

available, and rock-pigeons and wild-fowl abound; seals also can be shot among the islands. There is excellent safe sea-bathing, and good hotels in the village.

To the north of Burtonport is a wonderful coast-line, offering an almost unlimited field for fishing, shooting and cliff-climbing, etc. It is within car driving distance, and will well repay a visit.

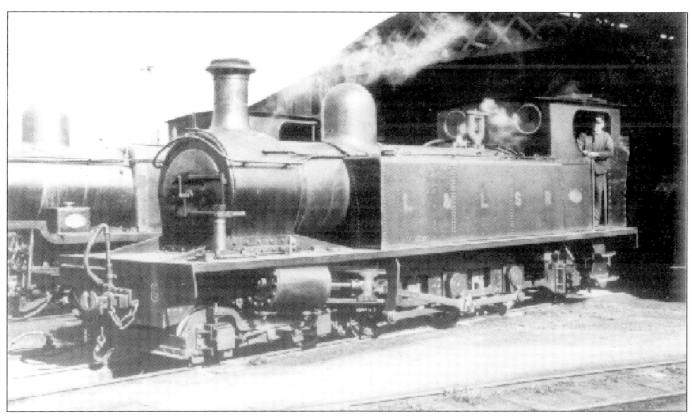

What extraordinarily graceful engines the old Lough Swilly Railway had! This lovely study of 4-6-2T no. 8 standing in front of Pennyburn loco shed on the 6th May, 1938 epitomises the finest aspects of the old company. She is fine order; clean but obviously well used, with steam just easing from her safety valve: all ready for another turn of duty to Buncrana, Letterkenny or the wild mountain passes of the Extension line to Burtonport. She is every inch a true lady, elegant fine-drawn lines containing an underlying sense of strength and power. We cannot help but be impressed. A beautiful loco exhibiting all the charm of her 19th century design. *H C Casserley*

Some Observations on the Light Railway

Quoted from *"Haunts of the Eagle"*

by Arthur W Fox

The book appears to be based on Fox's visits to Donegal some 25 to 30 years before its publication in 1924.

"Mr Harkin was very full of the advantages which the extension of the Loughswilly light railway would bring to this part of the county. The light railway has since come into being, and no doubt fulfils some of his prophecies. But by a singularly false piece of economy this single-gauge line traces vast expanses of bog, and with one, or perhaps two, exceptions has succeeded in carefully avoiding the chief towns and villages, which it was intended to serve. For example, it is nearly two miles from the important village of Church Hill, a full mile from the historic hamlet of Kilmacrenan, though it does pass near the Holy Well of Doon, and so benefits a numerous host of pilgrims. When it reaches Creeslough, by what can only be called 'Hobson's choice', it does actually pass through the village, which indeed it was impossible to avoid. One length of the line runs over a long viaduct through Barnes Beg Gap, and its foundations are so shaky that no trains are allowed to travel more than four miles along its trembling course! The line then runs through the bog four miles away from the important small town of Dunfanaghy, about three from Falcarragh, and so on until it ends in Burton Port, a great fishing station for northern Donegal.

"Before this ingenious means of burking traffic was constructed, I arrived at Dunfanaghy in time to meet one of the principal shareholders and the surveyor, the former a weedy-looking old Irishman of most courteous manners but entirely free from the national generosity, the latter a neatly built handsome Dublin-man, who has since passed beyond the reach of all railways. In the midst of our conversation, forgetful of the proverb that 'Proffered service stinks', I offered to show them the most solid course for their work, as I knew every inch of the bog lying beneath Errigal and

In the late 1940s the long-threatened Extension Railway was finally closed for good and the track lifted on the surviving section from Gweedore right back to here, at Letterkenny, the end of the line and the end of an era. *H C Casserley*

its fellow-heights. I took out the Ordnance Map and pencilled out a route, which, had it been followed, would have afforded firmer ground for the line, and been of far greater service to the inhabitants of the district. But as has so often happened in the case of well-intentioned schemes for the benefit of Ireland in the past, the course which I suggested was scouted as being too costly, with the natural consequence that the plan adopted proved to be alike more expensive and less serviceable. The station at Cashelnagore, for instance, lies in the heart of the bog near the foot of Altan Lough, and is chiefly useful to those who desire to get one of the two finest views of the stately cone of Errigal."

"The two railway proprietors and myself were the only guests: the elder of them asked me where I had been during the storm. When I told him, he poured forth a dismal story of the plight of himself and his friend, who had been caught while they were crossing the open bog, where there was not so much as 'the shelter of a haystack'. They had both got wet to the skin, and for himself, like Lord Ullin in Campbell's ballad, he 'had been left lamenting'. Nor was he in the slightest degree comforted when I unfolded to him my simple philosophy of life; that there was always one satisfaction in getting wet through, that you cannot get any wetter, while you have always the opportunity of

observing the annoyance of those who have not completed the process. Indeed he interrupted me with something that sounded like 'Amen', and hinted a wish that I might imperial my eternal salvation. At the familiar monosyllable the two dogs peeped shyly into the room: but seeing their foe they gave a simultaneous yelp and vanished into the night. In due time, after a does of 'the materials', in which the elder joined because it was not at his own expense, we retired to our several chambers, they to dream of great fortunes made by the forthcoming light railway, I of the wonders which I had seen that day."

An alternative route?

"At the time of the Burtonport extension to the Londonderry and Lough Swilly Railway, the 5th Earl of Leitrim worked very hard to get the line to come through Ramelton and Milford to Mulroy and then to Creeslough and West Donegal. His idea was to bring the trade from West Donegal through Mulroy instead of via Derry. The line was, however, eventually built via Kilmacrennan in 1903"

Quoted from *Mevagh Down The Years*

by Leslie W Lucas

Originally published in 1962 and with a third edition in 1983.

The Letterkenny and Burtonport Extension Railway

Part One
Letterkenny to Falcarragh

By the turn of the century government funding had provided the resources for the construction of the long winding line from the Lough Swilly's terminus at Letterkenny through the wild highlands of north Donegal to the remote fishing harbour of Burtonport. The Letterkenny and Burtonport Extension Railway was officially opened on the 9th March 1903.

The primary aim of the state-built lines through the "congested" districts was to encourage commercial activity in the key areas of fishing and agriculture. Thus it was that this line was laid out to take the easiest route to Burtonport. It was only incidental that it passed near any of the towns and villages of the region. Although a few of the intermediate stations did pass near the communities they served most were several miles away from centres of population.

Unfortunately, the fishing industry and agricultural produce never generated sufficient traffic to ensure the line's commercial success and the revenue gained from passenger workings never justified their operation. The Extension always had a parlous existence and, after just 35 years of operation, the company moved to close it completely.

The authorities' first attempted to close the extension in 1940 and the track was lifted from Burtonport back to Gweedore but, due to the war, the lack of proper roads and local protestors, the line from Gweedore to Letterkenny was re-opened on 3rd February 1941 as a freight line only. The Extension survived for another

six years carrying mostly cattle, turf and some fish but finally closed in June 1947. The remaining part of the Swilly system closed on the 1st July, 1953.

As you retrace the route of the Letterkenny and Burtonport Extension Railway look out for the round crossing gate pillars with round caps. These pillars can be found all along the trackbed and, together with the typical crossing gate-keepers' houses, can help identify the course of the line.

A pilgrimage to the past
Letterkenny to Kilmacrennan

 Drive to and park in the bus and car park at what is now Letterkenny bus station adjacent to the Quinnsworth shopping centre.

Like so many old railway sites in Ireland the buses now use the ground once covered by railway tracks, platforms and goods facilities.

Letterkenny once boasted two adjoining railway stations and the area now used by the buses is only a small part of the ground once covered by the iron road.

We start our journey near the Station Roundabout in Letterkenny (*Leitir Ceannain* – the hillside of the O'Cannons).

Here you will see a green-painted building. This was the terminus of the County Donegal Railway's line from Strabane. Behind it, in the area now used as a bus yard, you'll see the CDR Goods Store.

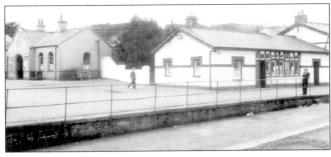

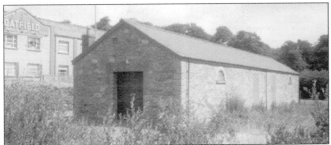

Left : The L&LSR station soon after closure. A E Bennett
Below left: The old CDR goods shed. ***Below:*** The old CDR Station House now the town's bus station.

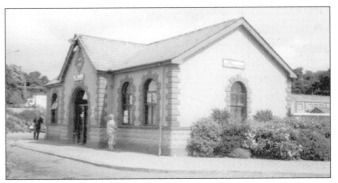

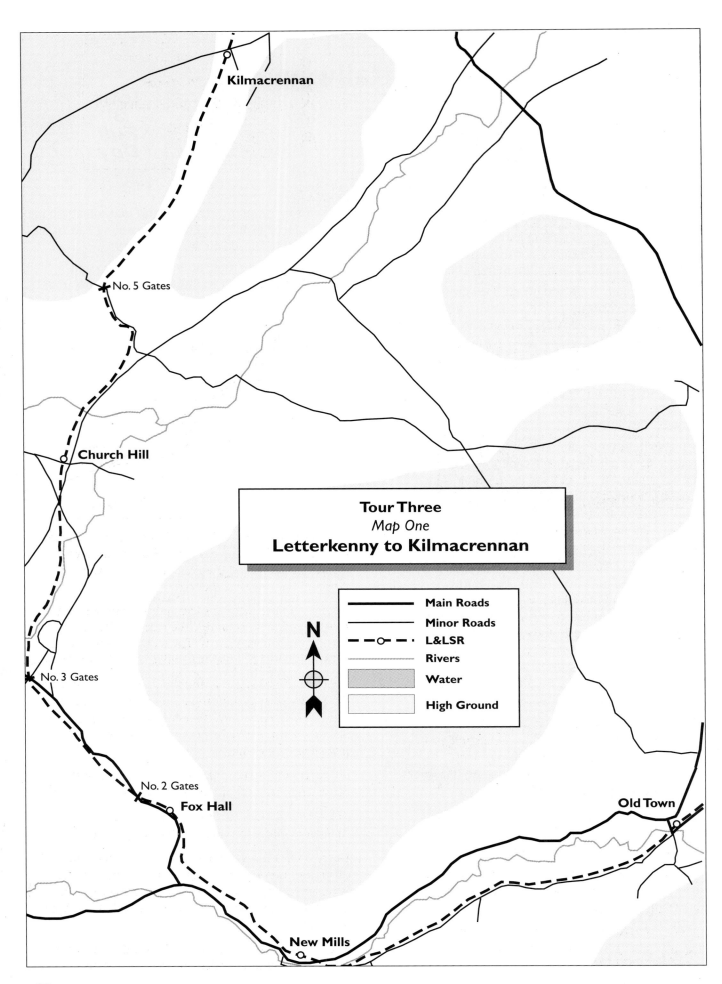

Kilmacrennan

No. 5 Gates

Church Hill

Tour Three
Map One
Letterkenny to Kilmacrennan

Main Roads

Minor Roads

L&LSR

Rivers

Water

High Ground

N

No. 3 Gates

No. 2 Gates

Fox Hall

Old Town

New Mills

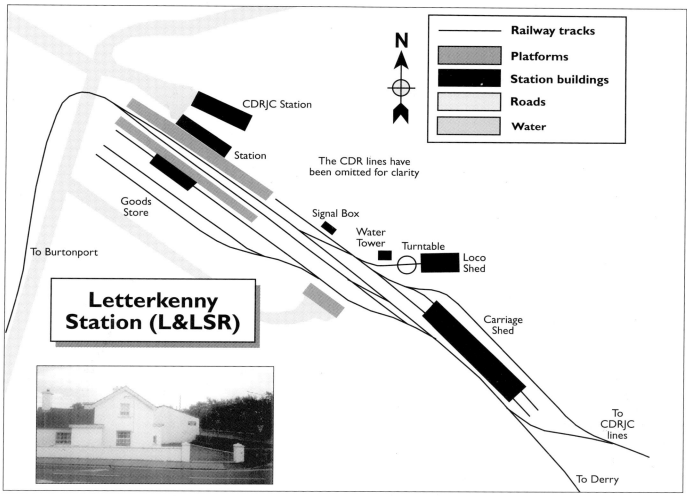

Letterkenny Station (L&LSR)

Map legend:
- Railway tracks
- Platforms
- Station buildings
- Roads
- Water

Labels on map: CDRJC Station, Station, The CDR lines have been omitted for clarity, Goods Store, Signal Box, Water Tower, Turntable, Loco Shed, Carriage Shed, To Burtonport, To CDRJC lines, To Derry

Above: Old Town Station at Letterkenny. The building, originally a crossing house, has been much changed over the years and there is little other railway evidence in this busy town.

If you face the old CDR station then, along to your right was the site of the Swilly station. It's been completely obliterated by the Quinnsworth shopping centre and car park. The road now occupied the route once taken by the old railway line and the cars now drive over the spot where the station buildings and platforms once stood.

The Burtonport line ran on from the Swilly station and immediately crossed the road by an ungated level crossing exactly at the point of the modern roundabout. It then ran on down the longest straight road in the town, Pearse Road.

 Leave the car park, enter the station roundabout and take the exit opposite the old CDR station westwards down Pearse Road.

You are now driving on top of the old track bed, the first section of the ninety-plus miles of the Burtonport Extension Railway.

 Drive along for about a mile until, at the end, you come to a mini roundabout [167109].

To the front of you is Dunnes Stores and to the right are the remains of the old Town Station, the first station on the line. A cut-stone boundary wall and crossing house still stand there.

Park in Dunnes' car park and, side-on you will see a fine metal bridge spanning the river Swilly that once carried the railway across. The store is on the north side of the car park and the bridge is on the south side.

There are many legends and much history attached to the Swilly river. According to local folklore the river was named after a local four-hundred-eyed monster named *Suileach* which was slain by St Columcille, from nearby Churchill.

However, a more plausible explanation is that the name came from the Irish for cloudy or dirty water.

St Columcille was also associated with Derry. He founded a monastery there in the sixth century.

Derry comes from the Irish word *Doire*, meaning oak grove. So, if you were using a direct translation of the [London]Derry and Lough Swilly Railway it would have been known as the "Oak Grove and Dirty Water Railway"!

The line then continued along the south side of the river for about three miles towards New Mills.

 Leave the car park and, at the mini roundabout turn right over the bridge and then immediately right.

This takes you out onto the Crieve Road past the Rockhill army base [145095].

The railway line ran beside the right-hand edge of the road and at several places you can see accommodation crossing gates beside the road.

Accommodation crossings were provided by the railway company when the line was originally built to give local landowners access to different parts of their land now divided by the track and to give them a way onto the road. The gates were kept closed to keep livestock off the railway line and were, in effect, private level crossings for the benefit of the railway's neighbours.

 Drive on south-westwards towards New Mills. After about two-and-a-half miles you'll cross a small humped-back bridge over a stream [127092].

Park nearby and walk back to the bridge and look to the left (north) of your direction of travel. You can see another metal railway bridge spanning the same stream. The track crossed this bridge and then swung away to the right (north) to cross the river Swilly again.

It then crossed the main road, the R250 Letterkenny to Churchill, by a fine cut-stone bridge which stood until very recently but was demolished in the latest bit of road improvement. Only one buttress now remains on the right of the road [126093].

Now continue driving on towards New Mills.

At about three-and-a-half miles from Letterkenny you'll come to the small hamlet of New Mills [123091]. Here, as you'd expect with a name like that, stands a corn and flax mill, formerly belonging to the Gallagher family. It has recently been restored by the Office of Public Works and is well worth a visit. You'll find references to the Swilly railway there as well as an old crossing gate sign and some original tickets – and we can thoroughly recommend the guided tour!

George Hegarty, who lives at New Mills Station House, told us an interesting story concerning a platelayer's trolley.

Late one evening George's father was shaving in a room at the rear of the station. As he peered into the shaving mirror, illuminated only by a small oil lamp, he heard a rumbling on the track outside. As the noise grew louder he realised it was not an unscheduled train but a runaway platelayer's trolley.

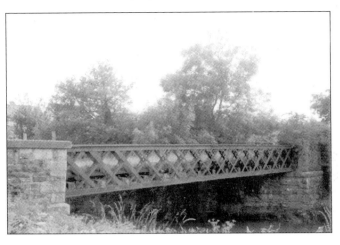

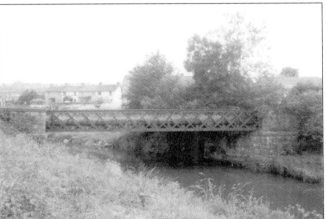

Both above: The old railway bridge crossing the River Swilly near the present-day Dunnes Stores. Note the substantial and long-lasting nature of the construction – an indication of the workmanship and skill that was put into the building of this lengthy line through some of Donegal's toughest terrain.

New Mills Station was situated on a 1:50 gradient which ran from the Swilly river past New Mills and up to Fox Hall Station.

Some children had placed the trolley on the track and climbed aboard. But, as it gathered speed on the steep gradient, they became frightened and jumped off. One little girl injured her leg as she struggled to get clear.

As the trolley sped past the station George's father (in a state of undress) ran out on to the track. He was just in time to see the trolley disappear down the hill. He knew that many people walked home along the track at night so he gave chase in an effort to catch it before it knocked anyone down.

He ran as fast as he could and finally caught it before reaching the overbridge on the main road. Fortunately, there were no pedestrians on the track that night and the trolley was recovered. Thereafter a stout chain was always attached to it to avoid any recurrence.

By the way, a platelayer was a railway worker who was responsible for maintaining the track itself. Every section of track, each "length", was the direct

responsibility of a particular worker, or lengthsman. Every day he would walk his length checking on the blocks that held the steel rails into the chairs that were, in turn, bolted to the sleepers. And whenever there was to be any major work then the playelayers would gather together at the particular spot and carry out the job under the control of the company's engineer.

Platelayers get their name from the days when railways were in their infancy and consisted of short lengths of cast iron rail carried on stone blocks buried in the earth. These "plates" were "L" or "U" in cross section, often only six feet long and were designed for horse-drawn wagons. So, although these wagonways, plateways or "railed" ways were transformed into the precision networks of the nineteenth century, the nomenclature of the workers, their equipment, and many aspects of the railways' equipment often remained the same.

 Back on the road, turn right over the bridge behind the mill. Immediately after the bridge you come to a T junction [123092].

Looking north, the track ran along the hillside up in front of you but it's very difficult to see. Two hundred yards to the right stands the one remaining buttress of the old road overbridge mentioned above.

 Turn left at the unsigned T junction and proceed along the R250 towards Foxhall.

Two hundred yards from the T junction you'll see a wide laneway on your right. This marks the old entrance to New Mills Station, which was situated up on the hillside overlooking New Mills itself. The platform was removed several years ago and there is nothing now of the station left to see.

Continue on the R250 towards Foxhall, the third station on the extension.

From New Mills to Foxhall the line climbed at a 1 in 50 gradient and swung north-west in an effort to circumnavigate Gregory Hill.

The trackbed ran along the right-hand side of the road but is hard to identify.

 When you come to a Y junction [106102] signposted Church Hill and Kilmacrennan to the right and Dungloe and Glenties to the left, bear to the right on the Churchill road (R251). You are now travelling north-west.

Within two miles from New Mills you reach Foxhall Station [103112].

By the way, Foxhall gets its name from the local estate.

All that now remains of the station here is the Goods Store, which was previously used as a community centre and is located on the right-hand side of the road.

Now carry on along this road and, half-a-mile further along, the line crosses the road on an S bend. There is a black-and-white painted crossing keeper's house on the bend [101113]. This spot was officially known to the railway as No. 2 Gates. From here the line ran along on the left of the road.

 Drive on for another mile and you'll reach a Y junction [091125]. Park somewhere safely nearby.

Walk to the crest of the hill and look towards Churchill. Down in the hollow you will see the blue-painted facia of the crossing keeper's house for, yes, you've guessed it, No. 3 Gates.

These Gates were a regular feature along the route of the line and were much more important than the accommodation crossings we've encountered already. Whereas the accommodation crossings were private accessways for local farmers the Gates were placed where the railway crossed public roads and were always staffed – opened and closed – by railway employees who lived in the adjoining houses.

Accommodation crossing gates were kept open for the railway and closed to the farm tracks until someone needed to cross. Crossing Gates, on the other hand were always kept open for the road and closed to the trains until it was time for a train to pass by.

Being a crossing keeper was a good job as it was a steady income, good living accommodation and, as there were few trains even in the railway's golden days, the work wasn't strenuous. But crossing keepers did have to know the railway regulations and any special instructions issued from time to time. Crossing keepers were often the wives of railway gangers who had their length of track to check and maintain each day. As the years went by the gated crossings sometimes became regular, though "unofficial" stopping places for passengers and goods. On the Donegal Railway, further south, even this was developed when diesel railcars were introduced onto the railway and it became possible to catch your train at, for example, Rose's Gates.

 Back to the car and bear to the right at the Y junction [091125], heading directly north towards Kilmacrennan.

The line stays on your left as it runs alongside the Glashagh River into Churchill Station.

 Keep straight at the cross roads [093153] and, at about three miles from the Y junction, you'll cross a humped-back bridge, Barrack Bridge, over the River Lennon [095169]. Stop nearby and get out to have a look.

Here, on the left, stands a nice collection of three bridges very close together. To the left of the first bridge the embankment has been completely flattened into a field although, to the right, it is still intact.

This led the railway on to the second bridge, a double-arched structure crossing the Lennon, and then over onto a cut-stone bridge spanning a minor road. Beyond this the embankment has again been levelled.

 Now drive on north-east for another three-quarters of a mile to Trentagh Crossroads [103167]. Turn left and drive for approximately quarter-of-a-mile.

You will pass through a collection of houses and a shop on a sharp left-hand bend. Stop just after the

Below: The three bridges over the River Lennon after Church Hill Station.

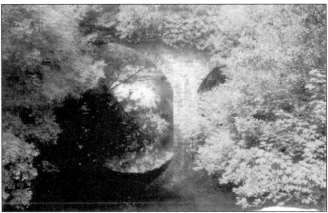

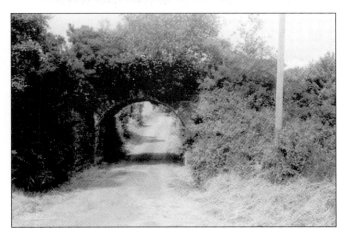

shop and you should be able to see a bridge on the left and the railway embankment carrying on towards Kilmacrennan village.

 Proceed on for another half-a-mile to where the old line crossed from the left to the right on a left-hand bend [097175].

You should now be able to recognise this as a level crossing (No. 5 Gates) complete with crossing keeper's cottage, with red-painted facia boards cut in the traditional zig-zag design.

On the other side of the road you'll see a turf shed. The roof is supported by four lengths of old steel rail and, judging by its condition, it was most probably a small part of the original Burtonport track.

The line now heads across some very rough country towards Doon and Kilmacrennan Station so you should now retrace your way back to Tentragh Crossroads [103167].

 Back at Tentragh Crossroads turn left towards Kilmacrennan Village. Turn left again at the crossroads in the village itself and proceed along the main road, the N56, towards Termon.

Just before leaving Kilmacrennan you'll see Lurgy Vale thatched cottage on the left, a great place to stop, browse through the collection of historic traditional farming equipment and have a cup of tea and a home-made scone or wee bun.

It's also a good time to pause and enjoy again the beautiful scenery and tranquil atmosphere of County Donegal where there's always time to stop, enjoy the view, breath in the scent of the turf fires and just unwind.

So, refreshed, relaxed and reinvigorated, it's time to get back to some serious railwayania as we follow the Lough Swilly Railway's steady climb to the Extension Railway's summit in the bleak turf moorlands.

 Continue along the N56 and, after about three-quarters-of-a-mile, turn left at the Y junction signposted "Doon Well, 3 miles" and "Doon Rock" [115197]. Drive along this road for a mile-and-a-half, ignoring the junction on the left for Doon Well [114197].

Just past this junction you will find Kilmacrennan Station on the left [113205]. The old Goods Store is in excellent condition and the platform is still in place. The station house has been renovated and there is a new bungalow on the track bed in front of the station, nevertheless the whole area is recognisable as an old station and still conveys that unmistakeable railway atmosphere, even in this relatively remote spot. (Remote? You ain't seen remote yet!)

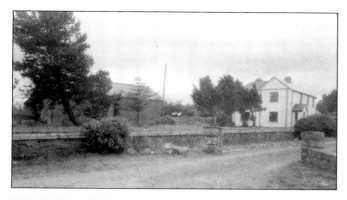

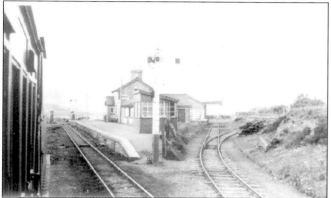

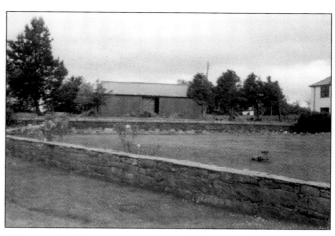

Above left: Kilmacrennan Station and platform. This station was often the scene of very substantial passenger excursions as people went on pilgrimage to the nearby Doon Holy Well. The well is said to possess curative powers and is signposted so you can visit it as easily today as in those of the Lough Swilly. *Above:* Kilmacrennan goods store. *Left:* The station in its heyday, photographed on the 23rd June, 1937 from the rear of the train from Burtonport to Letterkenny and Derry. All of the station fittings and equipment look in excellent order and the track is well maintained. *H C Casserley*

Kilmacrennan was quite a busy station at one time. It had a siding for bog ore traffic and it was the stopping place for pilgrims heading for Doon Rock and Doon Holy Well whose waters are reported to have healing powers. The Rock of Doon is where the ancient chiefs of Tyrconnel (the O'Donnels) were crowned. Special pilgrim trains were run to this station not only by the Lough Swilly Railway but also by its narrow-gauge neighbour, the County Donegal Railway. The line crossed the road and headed north up the valley towards Termon.

Drive past Kilmacrennan Station for half-a-mile and then turn right at the small crossroads [106203] onto a narrow road. You are now driving directly north.

Where the wild wind blows
Kilmacrennan to the Barnes Gap

Stop on the narrow road and look back for a good view of Kilmacrennan Station. Look forward and you'll see Drumlurgagh Hill. The old railway ran in the valley behind this hill.

Drive on and you'll very shortly reach a T junction at the end of the road [109224]. Turn right along the R255.

About 100 yards along this road you should see a white crossing house on the right [114221]. The railway crossed here from right to left although there is now no evidence left of its doing so.

Continue on. When you reach the main road, the N56, turn left. The junction is signposted for Creeslough (left) and Letterkenny (right). Drive on north-west through Termon village.

There is another crossing keeper's house on the minor road to the left at the end of the village [108232], but there's no need to leave the main road to see this one.

Then you enter a long straight stretch of road with the vista of mountains ahead of you in the distance and the clear notch of the pass through the Barnes Gap. In Irish *Bearnes* means gap or pass, so when the mapmakers came to write down the names they simply asked the local people what it was called. They told them that that bit of the mountains was "the Gap" (in Irish of course), and so Barnes Gap it became. (In Britain, Avon rivers follow the same pattern, *Afon* being Celtic for river!) Further south the County Donegal Railway traversed the Barnesmore Gap (*Bearnes mór* - the big gap).

The mountains either side of the Barnes Gap are Stragraddy and Crockmore.

About half way along this straight road the railway line and the modern roadway converge [102238]. The line then crossed the road on a level crossing and then ran along on the right-hand side.

This was the site of No. 8 Gates and of Barnes Halt, which stood from 1912 until 1940 [102238]. Today only the familiar crossing house stands with a long grassy bank to its front – the old platform.

63

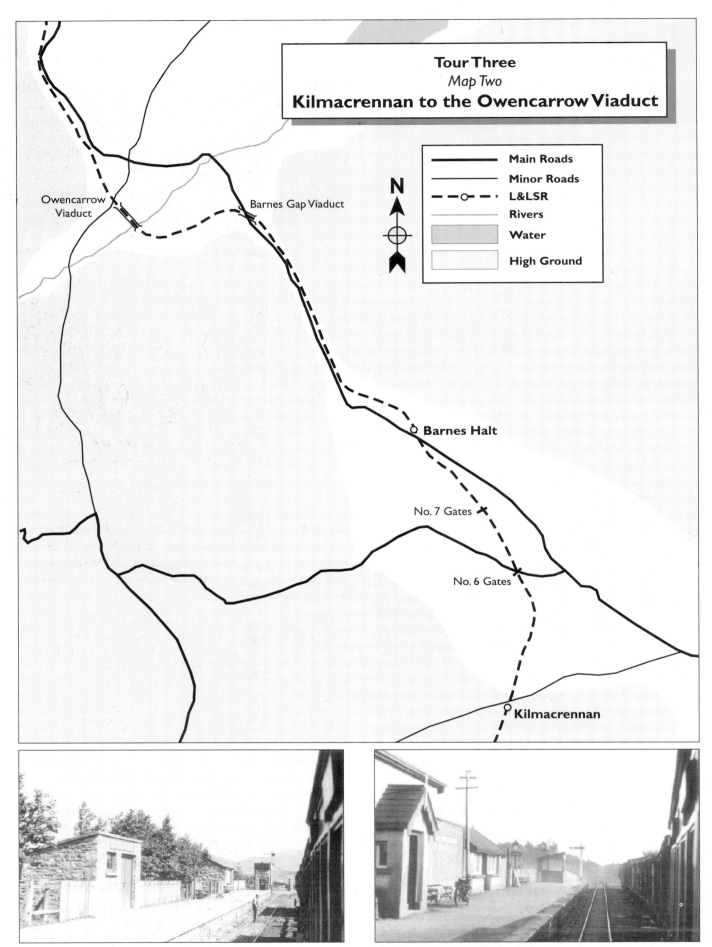

Tour Three
Map Two
Kilmacrennan to the Owencarrow Viaduct

Main Roads
Minor Roads
L&LSR
Rivers
Water
High Ground

N

Owencarrow Viaduct

Barnes Gap Viaduct

Barnes Halt

No. 7 Gates

No. 6 Gates

Kilmacrennan

Above: two further views of Kilmacrenan Station, taken on the 23rd June, 1937. *H C Casserley*

 Drive on a little further and you go round an S bend and into the mouth of the Barnes Gap itself [093242].

The trackbed now suddenly appears on a cut stone embankment on the right-hand side as the road rises to meet it, and then they run close together for over two miles in a north-westerly direction.

Even on the sunniest of days the Barnes Gap is a bleak rock-strewn area and it must have been particularly forbidding on a wild winter's night with the wind blowing a gale straight through from the Atlantic and only a small steam engine labouring along wet rails to get you home. You can clearly follow the trackbed right along the Gap as it will take many years or considerable labour to obliterate the trackway cut into the solid granite, a salutory reminder of the epic engineering work that was needed to bring railways into this remote part of Ireland.

At the north end of the Gap, as the sides begin to widen out, the road drops down and the track swings across from the right to where the road originally ran

Both below: The Barnes Gap viaduct carried the railway over the roadway at the north end of the mountain pass. The stone structures of the Extension railway are some of the most impressive and enduring reminders of times past.

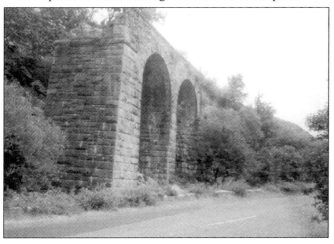

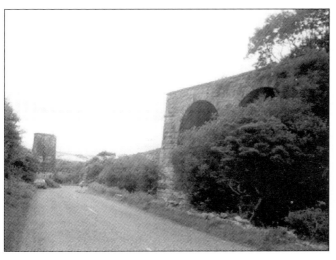

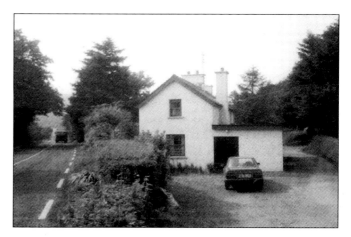

Top: Barnes Halt, in its modern guise. *Above:* Crossing through the Gap in 1937, looking south. *H C Casserley*

under a cut stone viaduct. It's worth stopping at this point for a photograph [082264].

Two arches still stand on the right of the road and a solitary pillar and a further arch mark the rest of the viaduct on the left of the road. The gaps between were once bridged by 60ft spans but these have long since been removed.

In the early 1900s, at the time of the Extension Railway's opening a stone quarry was started at Barnes Gap to bring out ballast. The need to reballast the track and maintain it to a high standard was highlighted when, in a peculiar accident back at New Mills on 16th September 1911, a carriage door which had been left open as the train moved was ripped off by the parapet of a bridge.

This showed the railway's engineer that the track itself was moving up and down as the trains rode over it tilting them from side to side and this would have been due to inadequate or poor-quality ballast – a mistake soon rectified.

After the Barnes viaduct over the main road the trackbed can be seen on the left as it veers sharp westwards along the hillside to turn northwards again towards the Owencarrow Viaduct. This was – and remains – the most spectacular and notorious engineering feature on the Letterkenny and Burtonport Extension Railway.

Follow the N56 up the hill to the Log Cabin bar [077271].

Park in the small car park across the road from the bar and look to the left (westwards) and you'll see the remains of the 380 yard-long Owencarrow Viaduct quite clearly with Muckish Mountain in the distance forming a highly-photogenic backdrop to this unique survivor of Donegal's railways. Muckish is shaped like a long rectangular block with a flat plateau-like top.

 Drive west for half-a-mile north along the main road from the Log Cabin until you reach the crossroads [069271 with the road to the left signposted to Glenveagh National Park.

 Turn left on this road to get a better view of the viaduct. Two hundred yards along you'll cross over a bridge [067266].

After passing over the viaduct the railway ran under the road here and headed further north. Park just after the bridge and look to your left for a good view of the remaining granite columns of the Owencarrow Viaduct.

On Friday the 30th January, 1925, the weather was so bad and the wind so fierce that the Burtonport train was blown off the viaduct! Amazingly only four of the passengers were killed in this dreadful accident which has become one of the more infamous stories about Donegal's railways. If you have experienced the sheer strength of the wind that can blow in Donegal then you'll understand why, to this day, people use sandbags to keep their roofs on! After all, there haven't been many trains bodily lifted off their track by the wind alone.

Some of the local people say that the granite pillars were built on a bed of sheep's wool as it was difficult to get a good footing for them in the boggy terrain – shades of Stephenson's crossing of Chat Moss for the Liverpool and Manchester Railway here.

Through moorland bleak and mountains steep
The Barnes Gap to Falcarragh

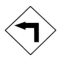 *Now to continue following the old trackbed we need to retrace our steps back to the crossroads at the N56 [069271]. Turn left towards Creeslough.*

The track bed is to our left and, at times, comes very close to the road and can be seen as an embankment while Muckish remains as our backdrop to the west. At this point both the road and the railway run in a north by north-westerly direction.

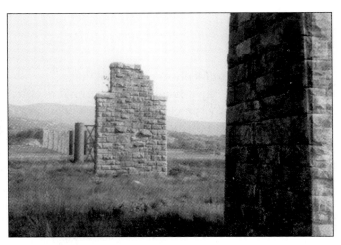

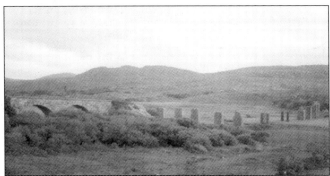

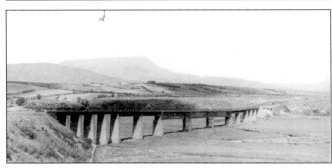

Top and Middle: The Owencarrow Viaduct, or rather the remains that still stand in mute testimony to the engineers and navvies who carried the railway across this wild and bleak moorland northwards to Creeslough.. ***Above:*** Owencarrow Viaduct, 1937. An anemometer was installed at Dunfanaghy Road Station, to the north. When the wind speed was too great all traffic was stopped. *H C Casserley*

Two miles along the road you'll now spot another crossing house on the left [058292]. This guarded the level crossing where the railway crossed to the right and three minor roads converged to join the main road. The line runs very close to the road along here.

A third-of-a-mile further on you'll come to a Y junction signposted for Carrigart, the R245 [059294]. Stop here and you'll be able to note Lough Natooey South on the left and another crossing house in the dip of the road in front of you. The line squeezed its way between the lough and the road and then crossed the road in the dip to the right. It then immediately entered a cutting, now guarded by an iron gate. This was the site of No. 10 Gates.

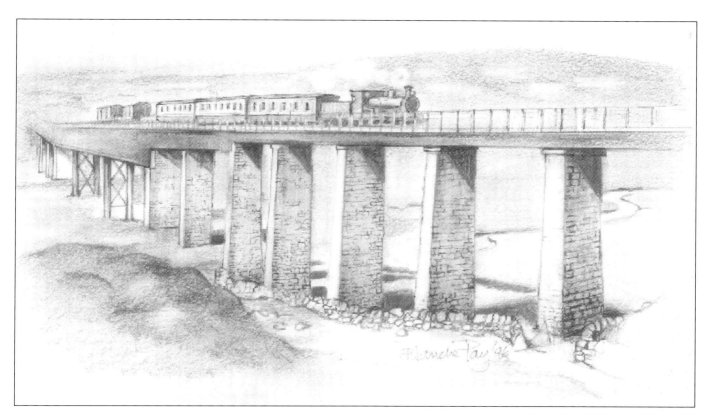

The Viaduct Disaster

D Hay

On a wild and stormy winter's night,
The little train did steam,
Adown past Kilmacrennan,
And Lurgy's purling stream.
She passed along down through the Gap,
The Ownecarrow she passd by,
Until she reached the hills of Doe,
Beneath an angry sky.

A sudden gust came from above,
Two carriages were swept o'er,
Three passengers there met their death,
Leaving hearts both sad and sore.
One other soul did pass away,
Her race on earth is done,
She died in Letterkenny,
At the rising of the dawn.

A band of noble heroes,
Came from far and near,
They worked to save the wounded,
With neither dread nor fear.
Bold lads from Kilmacrennan,
And from the vales of Doe,
Worked hard and sore together,
In that valley full of woe.

Near the village of Falcarragh,
There are hearts both sad and sore,
God help that distressed family,
On the Isle of Arranmore.
I hope and trust the wounded,
Will soon be strong again –
That they will all recover,
From all their grief and pain.

God help that little family,
Living up beside the Gap,
Tey lost their loving father,
In that unfortunate mishap.
I can't mention individuals,
But must give praise to one and all,
Who helped in the disaster,
'Mid the hills of Donegal.

The officials of the Railway,
Worked hard with craft and skill,
Each one did play a noble part,
Their duties to fulfil –
To assist the sufferers in distress,
In their lonely, weary plight,
Long will our memories wander back
To that stormy winter's night.

Above, top to bottom: 1 – Looking very much the typical Donegal home, Creeslough station in 1995. *2* – Creeslough Station in 1937. *H C Casserley* *3* – No 12 leaves Creeslough on the 8.30am from Burtonport to Letterkenny on the 24th June, 1937. *H C Casserley*

From the dip drive up the hill and into Creeslough. Just past the 30 mph signs, at the petrol pump, turn right down the hill. This will take you down to Creeslough Station [064304], two hundred yards from the road junction.

Stop somewhere safe just before the humped-back bridge. You'll see Creeslough Station building with blue and green gables on the right. The line ran from the station, under the bridge. Drive over the bridge and around the corner. In the Council yard behind the station you'll see the remains of Creeslough Goods Shed perched on the platform.

Return again to the petrol pumps on the main road and turn right towards Dunfanaghy. Drive through the village on the N56 [061305].

At just under a mile from Creeslough the railway embankment appears on the right of the road [057313]. At this point the line went over the small cut

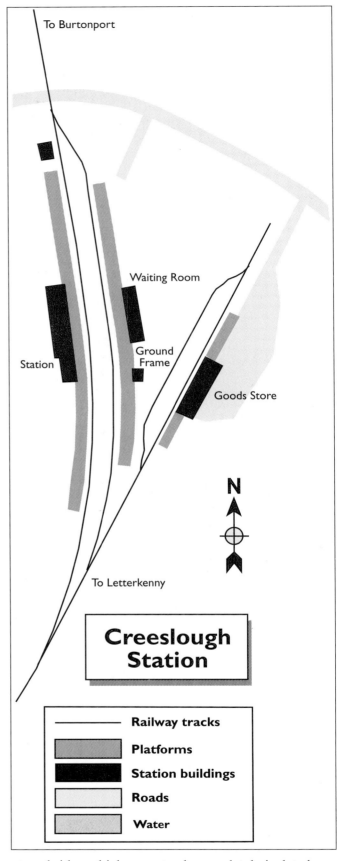

stone bridge which now stands completely isolated as the embankment itself has been removed from either side.

The route is on through the point where a modern bungalow now stands.

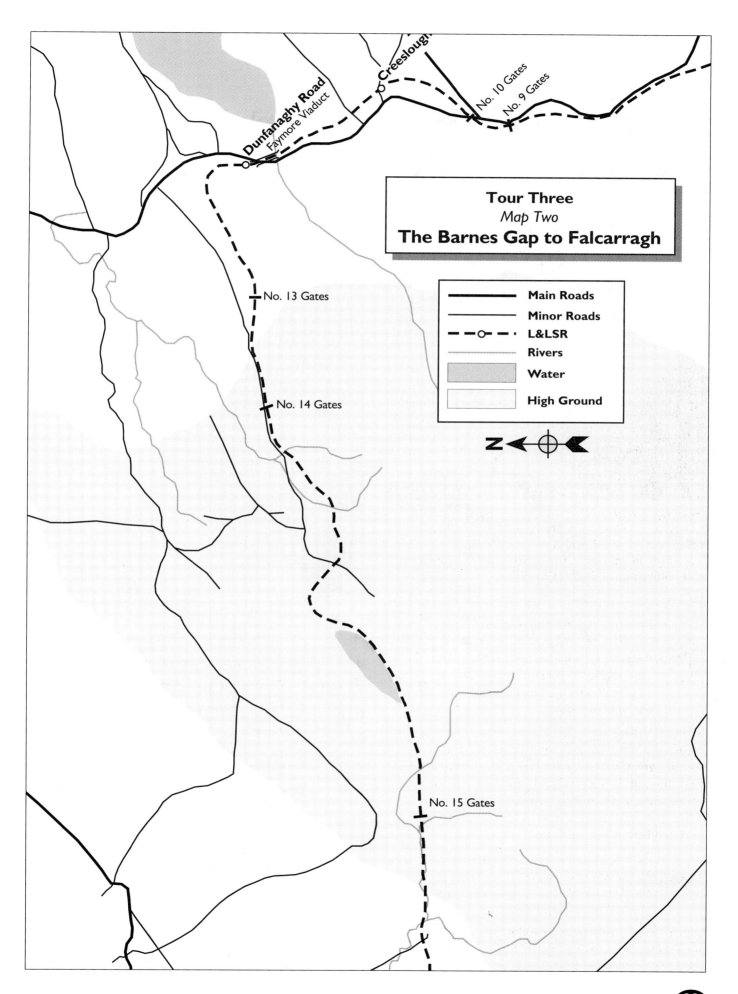

Dunfanaghy Road

Faymore Viaduct

Creeslough

No. 10 Gates

No. 9 Gates

Tour Three
Map Two
The Barnes Gap to Falcarragh

	Main Roads
	Minor Roads
	L&LSR
	Rivers
	Water
	High Ground

No. 13 Gates

No. 14 Gates

N

No. 15 Gates

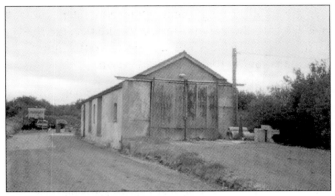

Above: Creeslough goods store, behind the station..

You should now be able to see the pillars of the Faymore Viaduct directly in front of you. The line crossed our road, the N56, on this 50-foot high viaduct and then immediately entered Dunfanaghy Road Station, known locally as Cloone Station as it was actually some way from Dunfanaghy itself (though right near the *road* to Dunfanaghy, if you get our meaning!). A modern bungalow stands on the site of the old station and nothing now remains of its railway past [054317].

However if you look carefully to the left you may be able to make out the cut stone pillar which stood at the station entrance.

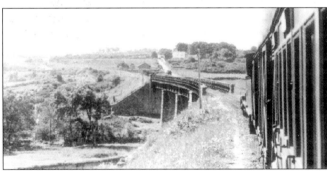

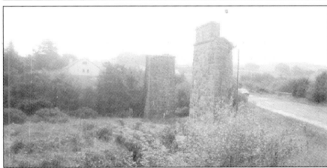

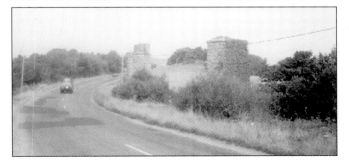

The station served Dunfanaghy, six miles distant but this is the nearest point to this well-known and popular north Donegal town. From here the line swung westwards across the bog behind Muckish.

 Continue on the N56 for just under a mile and, at the graveyard [051329], turn left up the narrow road. You are now travelling south west.

A further mile up this road you should see another crossing house on the left soon followed by and embankment and then a cutting as the railway builders sought to keep the line as level as possible in this increasingly wild terrain [041319].

Two hundred yards further still there is a small stone culvert with the high embankment over it. The line is very close to the road at this point.

As you drive up the hill there is a further crossing house on the left [034319].

The trackbed carries on beside the road at the same level and runs through a cutting opposite the gravel quarry [023316]. Another steep embankment then a cutting in the distance means that you are now heading out into a very bleak and boggy landscape.

Left: **1** – Faymore Viaduct seen from a Letterkenny-bound train in 1937. *H C Casserley* **2** and **3** – All that now remains of the viaduct today. *Below:* Approaching Dunfanaghy Road Station after crossing Faymore Viaduct. *H C Casserley* **Bottom:** The site of Dunfanaghy Road Station.

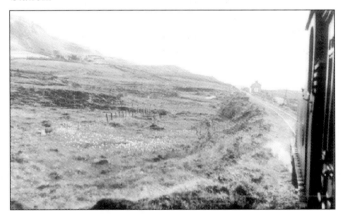

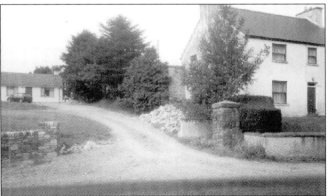

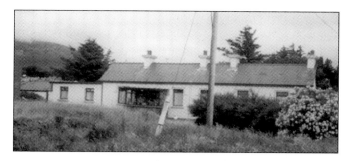

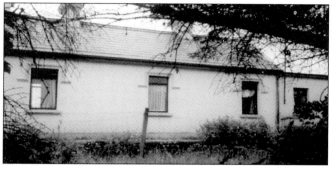

Both above: Falcarragh Station, another of the "cottage" style stations so familiar along the Extension Railway.

You eventually cross a cattle grid [015313] at which point you can see some long sections of railway embankment to your left. We are now well behind Muckish Mountain and into an increasingly barren area. At exactly 3.3 miles from the main road [009309] you'll see the track curving around from the left, cross the road and carry on to the right as it curves back around towards Lough Augher.

 Don't try to go on! Turn around and head back along the road you just travelled down. Ahead, the road just peters out into bogland a few hundred yards further on. Trust us. We know!

Anyway, after turning round, retrace your steps (or is it wheels?) for about half-a-mile and take the first road on your left [015313]. You are now travelling north and again you'll cross over a cattle grid.

 Drive on as straight as the road will allow (!). These are very narrow roads. You should pass two minor junctions, always bear to the left at these. At about one-and-a-half miles, just after the signpost for Lough Augher [012328], take the road to the left at the junction so that you are now driving due west.

This road immediately goes over a small bridge spanning the Kildarragh River. The railway line is now away on the left, out of sight behind Croaghlosky.

 A mile-and-a-half along this road, bear to the right at the Y junction [995322]. This will eventually take you back to the main Falcarragh Road, the N56, driving north west. Phew!

After turning, stop at the top of the hill [993322] to admire and enjoy the spectacular view of the north Donegal coastal area, the sea and the islands. On a clear day (you should have been here yesterday …) there is a lovely view of Horn Head to the right, white breakers on golden beaches in the foreground and Tory Island in the distance.

The old railway line is now away over on the left as it makes its way out of our view towards Errigal. But it's a bit of the route we can't follow, at least not unless we want to slog it over turf bog and rock scree for several hours!

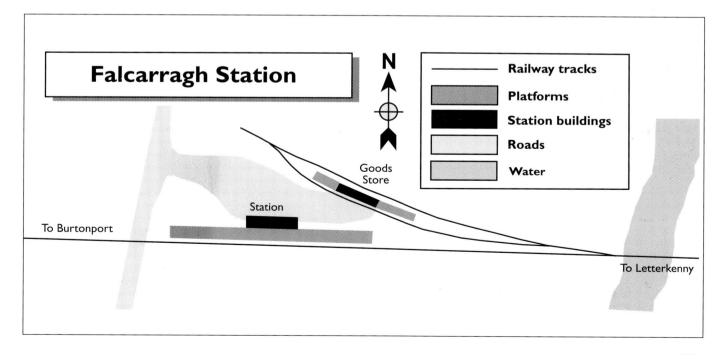

 So we stay on this road and follow it for almost four miles to rejoin the N56. Turn left when you reach the main road [993338], towards Falcarragh.

There's a small river bridge near this T junction, known as Macallig's Bridge.

Just before you enter Falcarragh town itself you'll come to the Old Rectory Pottery on the left. It's a good place to stop for a cup of tea and see some of the potter's work, and perhaps buy a memento or two.

You have now reached Falcarragh, deep in the Gaeltacht and one of the areas of Ireland where the Irish language itself is commonly spoken by the local people.

After pausing for suitable refreshment we'll push on to hunt out the old station.

 To find Falcarragh Station turn left at the crossroads in the middle of the town and then bear round to the right at a small bend in the road.

Two miles out from Falcarragh, at a place known as Fiddler's Bridge, you'll see the old station on the left [956301].

 Turn left immediately behind the station.

As you round the corner you'll be able to see the platform through the hedging.

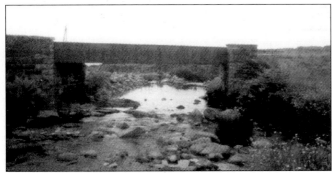

The bridge beside Falcarragh Station.

Carry on along the road for about 100 yards.

You'll be able to see a rusty metal railway bridge which the road actually crosses and then follows the trackbed for a few yards.

Stop near the bridge and walk back onto it.

You are now standing on the actual trackbed of the Letterkenny and Burtonport Extension Railway. Look towards the station and you can see where the track crossed the metal bridge and then ran in along the platform. It then crossed the road and continued on towards Errigal.

At this point one of the locals told us about a man who was badly injured by a passing locomotive, to the east of Falcarragh Station. The man lost his left foot and right leg below the knee when he was caught by the train while walking the track between two steep embankments. When asked why he didn't run to escape the engine, he replied "If I couldn't beat it on the level, how do you expect me to beat it on the hill!"

It's well worth continuing on along this road back to Falcarragh in a circle.

 After crossing the metal bridge the road swings to the left. Follow it round for 200 yards and stop [958304].

Look back (to the right) along the embankment and you'll see the white gable of a crossing house: No. 13 Gates.

A short distance further on and you pass by a collection of houses on the right-hand side and there you will find the basket weaver's house.

 Follow the road around to the left and drive on down to be back on the main N56 road, joining it near the Old Rectory Pottery we mentioned earlier. Turn left and drive through Falcarragh again.

Or indeed, stop. Here would be an ideal place to pause to gather your thoughts, reload the camera and sample the local fare.

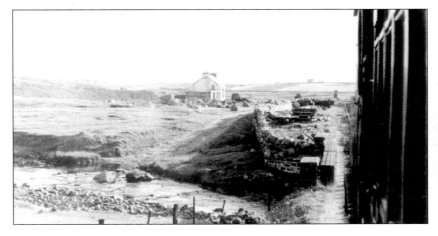

Left: The bridge at Falcarragh photographed from the train heading for Burtonport on the 23rd June, 1937.
H C Casserley

The Letterkenny and Burtonport Extension Railway

Part Two

Falcarragh to Burtonport

Amongst the ruins and the rain
Falcarragh to Gweedore

Falcarragh has several fine restaurants, some take-aways, hotel and B&B accommodation.

If it's a hot day (and even if it's not!) we'd recommend at least a reviving ice cream cone from the Falcarragh Service Station.

And you'll probably see at least one of the familiar red and cream coloured Lough Swilly buses. Yes, this is the old railway company still in existence, still carrying passengers and freight throughout northern Donegal. Look for the small writing on the side of the bus, near the front, and you should see "Londonderry and Lough Swilly *Railway* Company"!

The L&LSR buses, lorries and vans still provide an important transport network. They still serve all the little towns and villages along the old routes, and many more besides. And unlike the old railway they now come right into the main street to stop. So, if you pass them on your way, give them a friendly wave.

We reckon that the company is unique in the British Isles, if not in Europe, in maintaining the commercial existence of a narrow gauge railway company since its first rails were laid.

The second leg of our exploration starts in Falcarragh itself.

Below:
On the road up to Cashelnagore Station. The Glenna river is in the valley on the right.

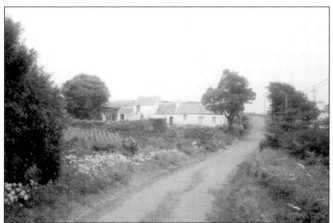

At this point the trackbed runs close to Errigal to the south of the town through some very rugged country where there are only a few accessible roads, more suitable for tractors than cars.

So we would advise that you drive along the main N56 road towards Gortahork [914302].

 After passing through the main part of this village take the first road on the left, just before the Spar shop and Shell sign [912299.

This road leads south and there is a sign at the junction reading *Teach Ruari* – Roary's House (Roary means a man with red hair, of which there are more than one or two in Ireland).

 One mile up this road bear round to the right at the fork in the road [914287].

There is a statue of the Virgin Mary at this point. The junction is named *Baile an Cheata, Baile* meaning town in Irish. There are a number of houses on this road but calling it a town is probably stretching a point.

This road runs on high ground and there are quite a few houses alongside it. You can look down into the valley to the right – the Aspick and Glenna rivers flow along the floor. The N56 runs out of sight on the other side of the valley and so we are now driving along parallel to that road and the rivers.

 A further mile brings us to another fork in the road, bear right here [916273].

Just at this fork there is a very nicely restored cut stone built cottage on the right.

Drive on past the school and telephone box on the left.

We now start to climb as we find our way to Cashelnagore Station, said to be the highest station on the system at 420 feet above sea level.

 Two miles on from the fork you round a sharp bend to the left and immediately go over a humped-back bridge under which the railway once ran [916246].

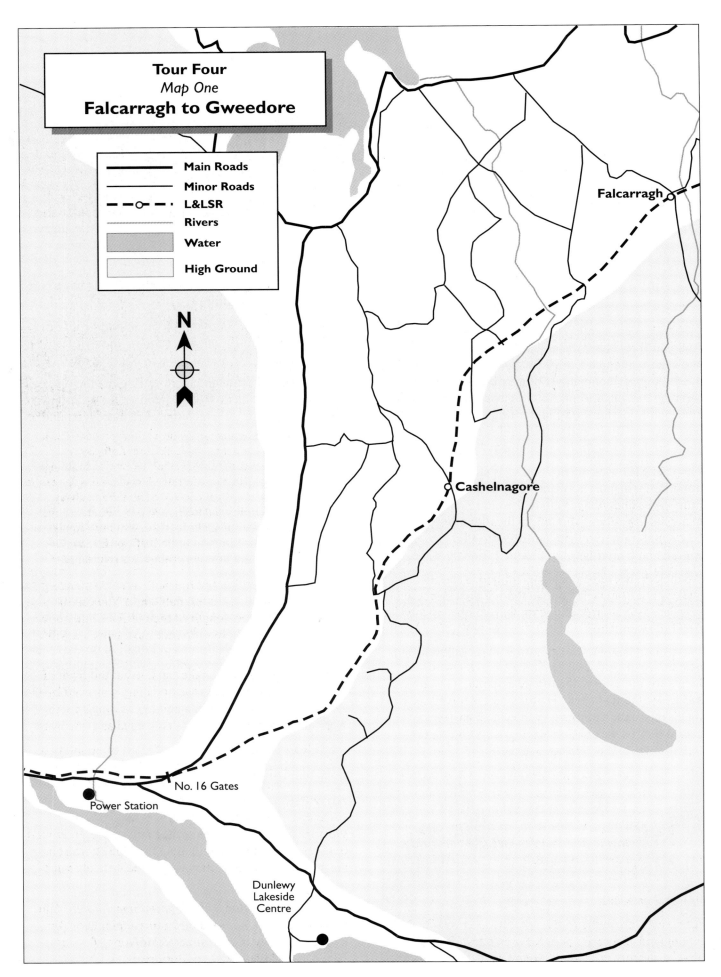

Tour Four
Map One
Falcarragh to Gweedore

Main Roads
Minor Roads
L&LSR
Rivers
Water
High Ground

N

Falcarragh

Cashelnagore

No. 16 Gates

Power Station

Dunlewy
Lakeside
Centre

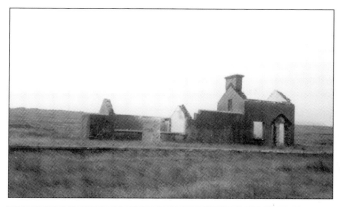

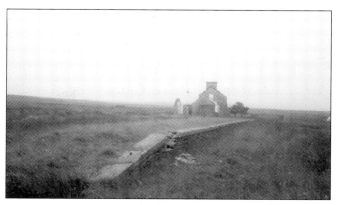

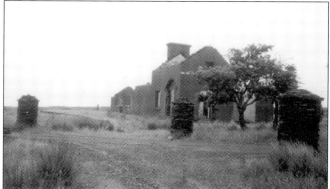

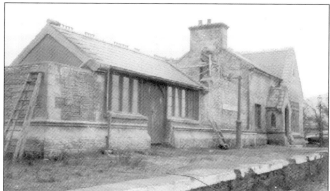

Perhaps the most remote of all the stations of what was a very isolated line: Cashelnagore Station. **Left, top to bottom: 1** – A general view showing the station buildings and platform. **2** – The view from the level crossing. Note the round gate posts. **3** – Again, looking from the roadway. **Top:** Amidst the ruins and the rain where the steam trains ran. **Above:** The station had a brief burst of publicity when it was cosmetically restored by the BBC for filming *The Railway Station Man*. It is now back to its ruinous state.

The station is derelict but the walls are still standing and the chimney on the left gable end. You can clearly see the full 200 feet length of the platform and, to the rear, it looks like there may once have been a small siding.

The road zig zags across the trackbed at the front of the station. The original road crossing is marked by the standard round stone pillars and the railway's route westwards from the station is now used as a roadway.

Cashelnagore Station had a brief burst of publicity a few years back when the BBC used it as a location when filming *The Railway Station Man* with Donald Sutherland and Julie Christie. The building was cosmetically restored to something like its former glory and various railway artefacts were placed around but these have now all long gone and the station has returned to its long sleep amongst the desolate wind-swept landscape.

Incidentally, the other main location used for the film was a cottage on the road down to the pier at Malin Beg, all the way over in south-west Donegal, near Glencolumbkille (CDR territory really!).

Look to the right and left at this bridge and you'll be able to see the old trackbed very clearly. One of the locals who lives near the bridge said that he was very sad to see the line close. He remembers travelling on the Swilly train en route to Scotland to gather potatoes. This was back-breaking work for the migrant farm workers who were known as "taty hokers".

 After going on over the bridge bear to the left for Cashelnagore Station. You pass a lake on the left, then Lough Agannive on the right. Ignore the small road on the right and then, one-and-a-half miles from the bridge, you arrive at Cashelnagore Station itself [926262].

Remote, or what!

It's completely in the middle of nowhere, surrounded by bogland. There are no trees or houses for miles around. A truly wild and desolate spot.

Retrace your steps back to the bridge and turn left just before crossing it. You are once more heading south.

This is a narrow road but just wide enough for one vehicle. Have fun!

The line runs on the right in a cutting, very close to road. You can look down into the cutting from the car (though mind the road – there's sometimes a car or tractor coming the other way, even in Donegal). Shortly, you'll see the line cross the valley on a fine embankment [914239] and disappear between two mountains, Truskmore and Binaneyne. There is a fine stone bridge set in the embankment spanning the Glenna River, which we met earlier.

As you follow the road it swings away from the railway embankment to the left. You are now driving on a narrow single-track road with grass growing in the centre. The road curves close to Errigal, on the left. Errigal itself is shaped like a volcano and has distinctive scree slopes of frost-cracked granite pieces. It's the highest of the many mountains in Donegal.

Now we pass Lough Nacreevagh [914224] on the right and, after two miles, come to a T junction where there are three houses [913215]. Turn right through the houses and then immediately left.

Top right: No. 16 Gates crossing house on the N56. A typical example of the standard L&BER crossing-keeper's house, now abandoned. **Below:** The railway embankment disappearing between Truskmore and Binaneyne mountains. **Bottom:** Errigal and Lough na Cung Upper.

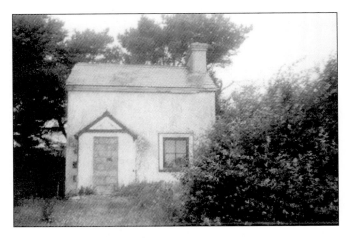

As you turn to the left you'll see Dunlewy Church and lough down in the valley.

Follow the road down into this valley and it'll join the Glenveagh to Gweedore road, the R251.

At the T junction [907205] Dunlewy Church is in front of you and the Lakeside Centre is a few hundred yards to the left. The Centre is really excellent and well worth a visit. We recommend the guided tour. And our old friend the Lough Swilly Railway gets a mention in the displays here as well.

After visiting the centre go back along the road and head for Gweedore or, if you're not going to the Centre but are waiting patiently at the T junction for your next directions for following the trackbed, turn right towards Gweedore! That is, westward ho!

You will soon see Lough na Cung Upper on the left [891211]. Before reaching the end of this long lough (or is that a tongue-twister?) the N56 comes in from the right at a Y junction [884219]. The railway crossed the N56 a little way up this road.

Go back north-eastwards along the N56 for half-a-mile to locate the crossing point.

When you come to a clump of trees beside the road – the only clump for miles around – then you should see an abandoned crossing house just there [891221]. The line crossed at this point (No. 16 Gates) and carried on, turning to parallel the road into Gweedore Station.

Reverse at the abandoned crossing house and drive along towards Gweedore.

The railway, running parallel to the road, can be seen high up on the right. The Electricity Supply Board turf-burning power station is on the left [875217]. Half-a-mile from the Y junction, just before the power station, you'll be able to see a fine stone overbridge on the right [879221]. Further along still, the once famous Gweedore Hotel is on the right. The track ran behind the hotel.

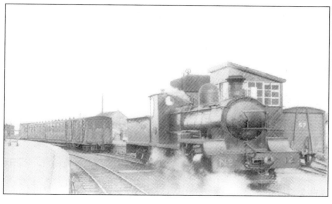

Two-and-a-half miles from No. 16 gates we reach Gweedore Station, on the right, at a Y junction [852226].

The line crossed the road just after the station and went immediately over a cut stone bridge spanning the Clady River. The two sides of the bridge still stand but the middle section has long gone.

Opposite this bridge, on the other side of the road, you can just make out the end of the station platform. The station building has been extensively renovated and is no longer recognisable as a railway building. However, if you walk around the right-hand side of the station house you can just make out the double platform at the rear of the building.

At Gweedore Station another local told us of his near-death experience back at Cashelnagore Station. He was about 10 years old at the time and was nearly killed when he was trapped between the crossing gates and a passing train as it steamed through the level crossing.

Top: Gweedore Station on the 24th June, 1937 with no 12 shunting freight vans before moving on towards Burtonport. *H C Casserley.* **Right, top to bottom: 1** – A view of all that now remains of Gweedore Station, much altered since railway days. **2** – The station in railway days. *H C Casserley* **3** – A second view of Gweedore today. **4** – Although further work is underway you can just make out the platform either side of the wall, displaying the site's railway past. **5** – The bridge over the Clady river at the far end of the platform, across the road. *Below:* The road entering Crolly village, the railway line ran between the sign and the house.

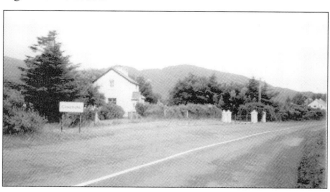

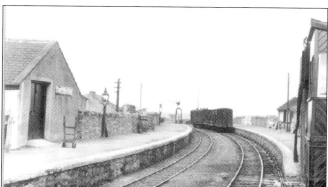

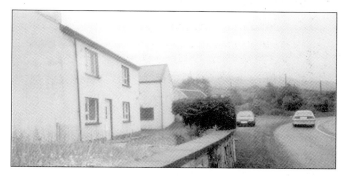

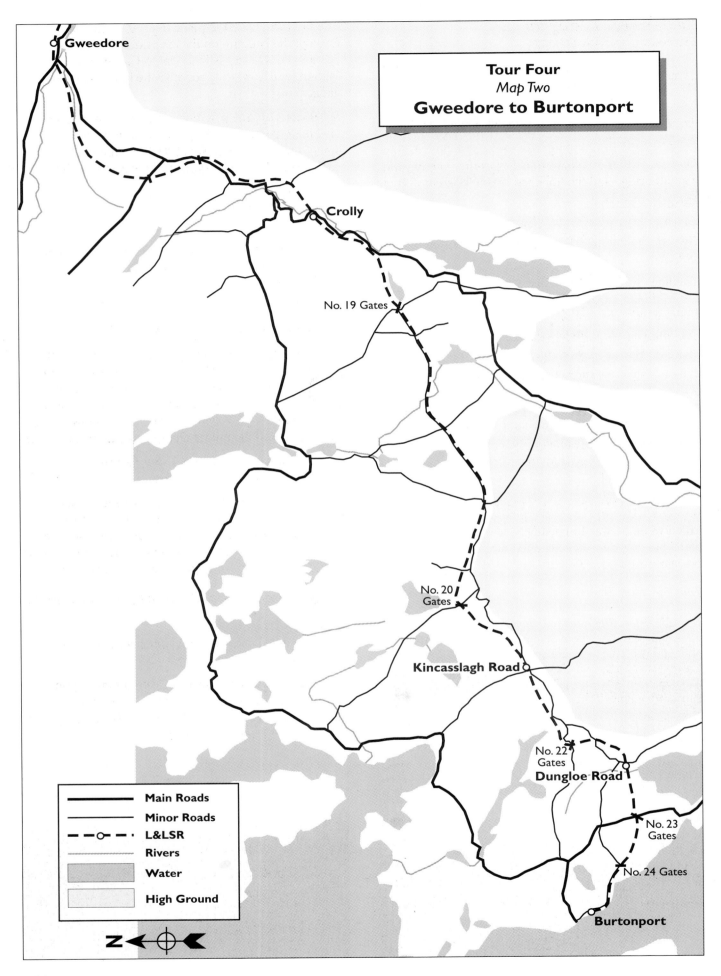

Gweedore

Tour Four
Map Two
Gweedore to Burtonport

Crolly

No. 19 Gates

No. 20 Gates

Kincasslagh Road

No. 22 Gates

Dungloe Road

No. 23 Gates

No. 24 Gates

Burtonport

Main Roads
Minor Roads
L&LSR
Rivers
Water
High Ground

N

To journey once again …
Gweedore to Kincasslagh

 Bear round to the left at the junction in front of Gweedore Station and cross the Clady River bridge.

The line is on the right, out of sight. You are again heading south west.

One-and-a-half miles on from Gweedore you may see a small bridge and the trackbed if you look carefully to the right [835213].

Drive on towards Crolly village and, just before entering the village, there is a sign for Crolly in Irish [838207].

At this point the line crossed the road and continued behind the crossing house. It then ran into Crolly itself high on the left.

Continue on through the village and keep on the N56 road, ignoring any turn-offs.

Half-a-mile from Crolly, as you round a left-hand bend, you will see a small stream and waterfall [829191]. The line ran over a metal bridge at the top of this waterfall. Then, as you round a right-hand bend on which there is a large boulder, you will see the line cross the road in front and immediately enter Crolly Station [829191].

Below: The crossing keeper's house north-west of Crolly village. **Bottom:** Crolly Station, south-west of the village. **Below right:** Riding the L&BER! The point at which the road swings up over the bridge and back down onto the trackbed on the other side.

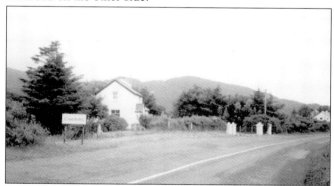

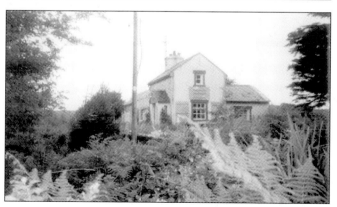

The platform is still in place but it is difficult to see through the hedging on the roadside. This station is occupied today and is identical to Cashelnagore Station, with a waiting room to the left of the station house.

After leaving Crolly Station the embankment becomes visible on the right and eventually four round pillars come into view. These supported accommodation crossing gates and are typical of the Swilly railway.

Still on the N56, a quarter-mile further on the track veers to the right behind Lough Connell and parts company with the main road.

 When you reach Loughanure village turn right at the crossroads, signposted for Annagary and Airport [785221].

Airport?!

Yes, the sign really does read "Airport"!

It's quite a fine regional airport at Carrickfinn with regular flights to Scotland, the Channel Islands and also flights to other parts of Britain. The much-loved Swilly steam train has been replaced by a big silver-winged bird. Any modern "taty hokers", if any existed, would speed to the potato clamps via the stratosphere!

Drive on for three-quarters-of-a-mile from Loughanure on this airport road.

You should eventually round a corner and see a dip in the road [811177]. As in previous "dips", the line crossed the road here and, on the left, you'll see the familiar shape of a white crossing keeper's house. Also on the right but out of sight is Lough Connell again.

 Turn left immediately in front of the crossing house.

You are now *actually driving along the old railway track bed!*

The road is narrow and uneven, deteriorating as you progress and giving the car's springs a run for their money. Look out for a lake on the left [801168]. If you're the passenger (rather than the driver!) close your eyes.

Imagine yourself in the cab of no. 12 steaming along here towards Burtonport, mind you at a very slow rate indeed. Stop for a moment.

Wind down the windows.

There! On the very edge of hearing. A steam engine's whistle, the steady chuff-chuff of the cylinders, the rattle and squeal of the wheels.

And, in the distance, you can almost see the puffy white steam rising, the crows wheeling and cawing through the smoke-smudged sky.

And then you hit a particularly lively pot-hole!

Two roads cross the old track at an interval of a quarter mile.

Eventually you drive along an embankment, pass a white house on the right, then enter a rock cutting.

As you emerge you'll see Heather Lough on the right [788172]. The track bed stretches out in front of you in a straight line.

In fact this length of trackbed-cum-road is *so* railway-like that, driving along here is the next best thing to actually being on the train or in the cab of no. 12!

You drive over another embankment, followed by a small cutting. Drive on this trackbed for roughly two miles, ahead lies a fine cut stone overbridge [781164].

The trackbed continues under this bridge but the road swings right and climbs up over the bridge and back down the other side to rejoin the trackbed.

It's difficult to see at this point if the road runs beside the trackbed or actually on top of it.

Eventually the line appears on the right and runs behind some houses higher up.

You are now deep in the area known as the Rosses, *na Rosa* in Irish. The land is barren and sprinkled with numerous loughs. Very scenic and very popular with visitors.

The track now veers to the right and the road swings to the left. Just yards after the railway route and road separate you'll see, up on the right, a conspicuous crossing house.

These were No. 20 gates. The house is just a few yards up from the road [766168].

Turn right up this little road to view the house.

At the crossing stands the familiar cut stone pillars guarding the entrance. However, here they are

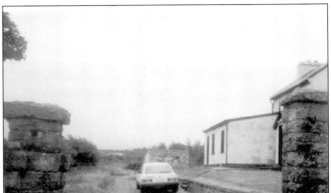

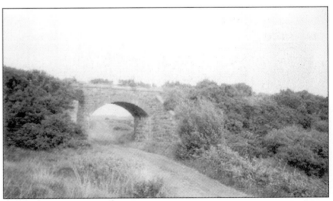

Above, top to bottom: **1** – Crossing Gates no. 20, the house stands out on the skyline. **2** and **3** – Closer views of the location and layout of no 20 gates. Many of these crossings evolved into semi-official halts in their own right as traffic slowly increased from the areas that they served and the railway operated a *de facto* "stop as required" policy which is still a part of Irish rural public transport. **4** – A good example of a typical L&BER road underbridge carrying the old railway over a minor road.

square, not round. A small platform is also visible at the front of the house. Stand on the crossing, look west along the track bed and you'll see an embankment and a bridge set into it. The line westwards along the embankment has been used by road vehicles.

Go back down to the main(ish) road and turn right towards Burtonport.

Within a short distance you will see a road to the right [765168] which takes you down to the bridge set in the embankment we noted earlier.

This cut stone bridge is worth a look as it's the first one we've seen with a red brick underarch.

Return again to the main(ish) road and continue on towards Kincasslagh Halt and Burtonport, heading south west all the time.

The track, meanwhile, runs through a cutting crossed by a main road and continues on the right-hand side through another cutting.

A station where you can still see much of the old railway's built environment: Kincasslagh Road Station. These four photos show the well-preserved platform, stone-built waiting room and the trackbed, now laid out in a lovely lawn. This sensitive and sympathetic treatment really summarises the best approach to County Donegal's railway heritage: utilising what's left to enrich our modern environment with a sense of the past.

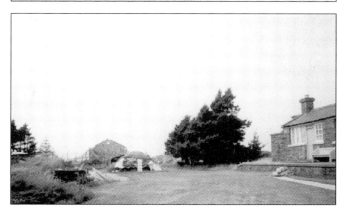

To Paddy's green shamrock shore
Kinncaslagh to Burtonport

Just past Meenbannad School you'll find a crossroads [756159]. Here stands No. 21 Gates and Kinncasslagh Halt, known locally as Meenbannad Station.

This is undoubtedly the best preserved and finest remaining of these small stations on the Burtonport railway.

It's a railway enthusiast's dream, making the whole journey well worth all the effort.

There are four cut stone square pillars at the crossing just as you enter the station. The platform is still very much in place with a timber picket fence along the rear of the platform. Part of a lamp standard can be seen, still on the platform and, at the far end of the platform, there is a beautiful cut stone building in perfect condition – probably the waiting room.

The station house stands in front of the platform, besides the road. Its typical of the Swilly design for the Burtonport line although extensions front and rear have been added. On the other side of the road there is a unique green-painted corrugated iron shop perched on the strip of ground between the road and Lough Altercan.

The road you crossed over at the crossroads is the Dungloe to Keadew Strand road and originally went between the crossing pillars and curved around the lough.

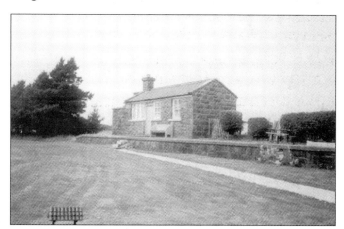

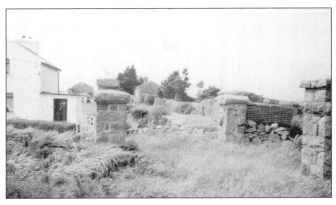

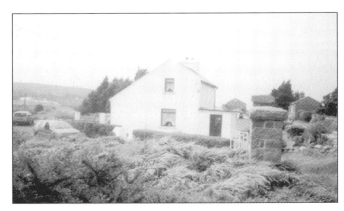

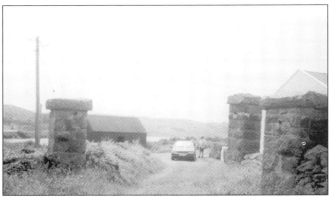

The owner of the old station said that this halt was opened in 1913 after the businessmen of Kincasslagh complained that Dungloe Road Station was too far away. So, from 1913, they brought their carts to Kincasslagh to collect their wares from the Goods Store here, part of which still remains at the end of the platform.

Kincasslagh today is the home of Ireland's most famous singer, Daniel O'Donnell. If the railway was still running I am sure it would be bringing loads of "pilgrims" to see Daniel's birthplace – quite apart from the experience of an amazing 96-mile journey on a narrow-gauge steam railway! Instead, the all-conquering road coach brings the adoring crowds to have tea at his Viking House Hotel.

So, while pleasantly dreaming of what might have been, continue along this narrow road westwards past the station and green shop.

The track is here on the right.

 After about three-quarters of a mile there is a Y junction marked by a sign showing a lorry and a three ton weight limit [749156]. You should bear left here.

However, if you want to examine the crossing house and pillars of No. 22 Gates continue to the right for a few yards.

 Bearing left at the junction drive south west below Cnoiceach Mor and continue for about a third of a mile to where the line crosses the road at a small unmarked crossing point and continues on towards Dungloe Road Station to the left [744153].

Above: Four more views of Kinncasslagh Road Station showing the station house and crossing gates. *Both below:* Dungloe Road Station, once a busy spot for local farmers and popular with anglers in the 1920s and 30s.

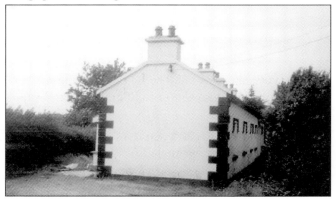

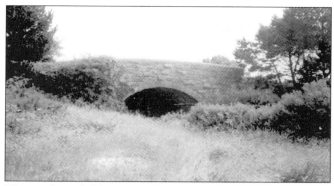
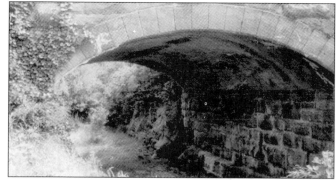

The road overbridge near Dungloe Road Station, the vantage point for a view of the station.

Just after the crossing, on the left, you'll see several of the familiar round stone pillars standing like statues in the barren bogland but there is no sign of any trackbed here.

 Another third of a mile further on and you arrive at a T junction [742145]. Here you would turn right for Burtonport but, so that we can locate Dungloe Road Station, we'll turn left and proceed for 200 yards until we meet another humped-back bridge [741144].

Stop near the bridge and look from it to the right. You'll see the station below and the goods shed in front of the station. In between these two buildings you'll see a row of small trees marking the edge of the platform which is now totally overgrown.

 Go back up to the T junction and this time carry on round the bend to the left on the main Burtonport road, heading north west. The track runs out of sight away on the left.

 Just at the Columbus Community Centre you meet the R259 road at a Y junction [732149]. Turn left onto the R259 and drive for almost half-a-mile.

Here you should find No. 23 Gates [734143].

The line did cross here but it's very difficult to find evidence of it. A crossing house does stand here but it is now unreckognisable as such. It is now a large two-storey house with three chimney stacks. The line would have passed in front of this house, over the road and continued on towards Burtonport.

 Return to the same Y junction on the R259 and take the road immedietly to the left, just after the Y junction [731149].

This is a very narrow road leading down to the sea (and ending at the quayside) which meets the railway at right angles.

At this meeting point, you'll see a crossing house with a sign above the door: "Gate House", in fact it is No. 24 Gate House, the last set of crossing gates before the railway reached Burtonport quay [718152].

On your left you will see the route of the track coming along the front of the house, cross over the road and continue on the right, this section of the old trackbed on the right is now a roadway.

 Turn right onto this roadway.

You are now driving north-west on the old trackbed. The sea is on the left and, at certain points, you go over bridged embankments where the sea flows underneath.

You drive through a small cutting before entering the railway's terminus at Burtonport [719151]. Just before the station itself you drive through a fish processing plant then, suddenly, on the left, you can see the engine shed, recognisable by its characteristic round-top windows and door.

Both below: Burtonport loco shed today and in 1937 with no 12 leaving with the 8.30am to Derry. H C Casserley

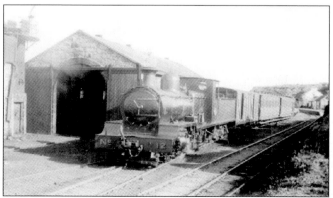

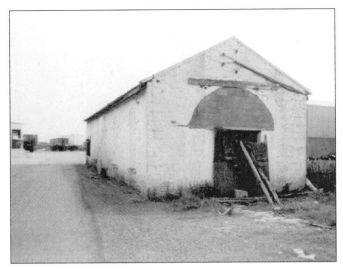

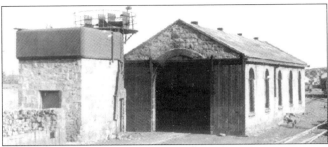

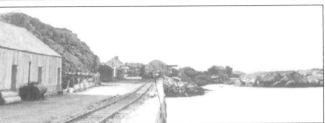

Above: Burtonport locomotive shed. *Above right:* Another look at the loco shed in railway days and, *right*, the somewhat bumpy siding that stretched on from the station along to the fish quay. *H C Casserley*

In the middle distance is the terminus station itself with a length of platform still in existence on the right-hand side of the road. The station house and offices still stand but are now derelict. They and the goods shed are now the only railway structures left at Burtonport.

Originally a siding ran along the quayside so that fish vans could be loaded directly from the fishing boats. Burtonport is still an important centre for Ireland's fishing industry but today refrigerated articulated lorries haul the catches to their markets. It's also from here that the ferry service runs to Aran Island, known as *Arainn Mhór*, Big Aran

There are several pleasant bars at the far end of the quay from the station buildings and, if you need the shops, they are on the road leading back up to the main road from that far end of the quay.

As you sit over a quiet pint and listen to the seagulls you might like to recall the cold, dark winter mornings when the fishermen returned with their catch and it was loaded onto the waiting train to be taken off to market. Just think of that long journey back through the mountains before the fish could receive their coating of batter and accompaniment of chips and buttered wad to become a fish supper!

You know, despite the relative slowness of the Swilly locomotives, when compared with today's lorries, some locals boasted that a fine catch of fish could be up for sale in London's Billingsgate Fish Market the following morning.

And you might also like to idle away an hour or two in imagining what it would be like if the Letterkenny and Burtonport Extension Railway were still running today. *What a tourist attraction! What a sight!*

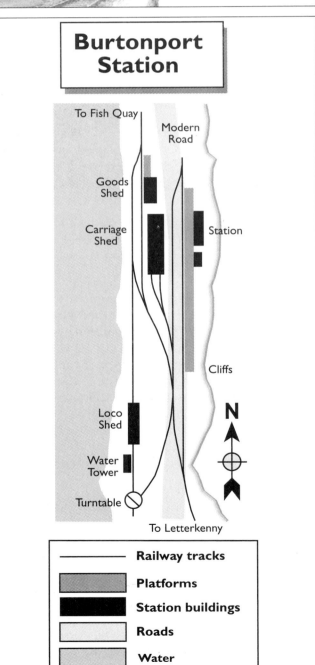

Burtonport Station

To Fish Quay

Modern Road

Goods Shed

Carriage Shed

Station

Cliffs

Loco Shed

Water Tower

Turntable

To Letterkenny

N

	Railway tracks
	Platforms
	Station buildings
	Roads
	Water

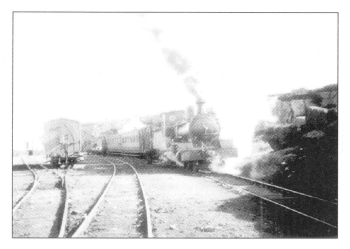
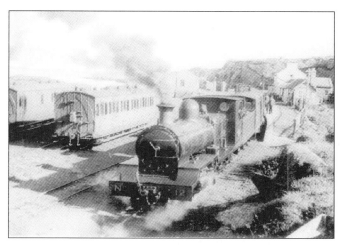
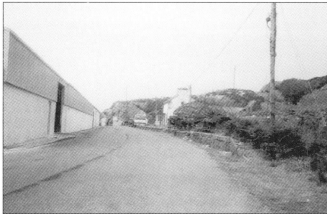
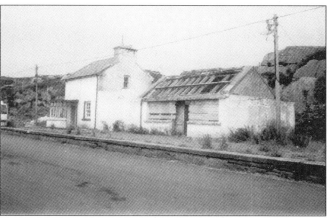

Some "then" and "now" photographs to complete our exploration of the Letterkenny and Burtonport Extension Railway. Although almost 60 years separate these pictures it's still very easy to capture the atmosphere of the railway on a visit to this important fishing port. **Top left:** No. 12 is just at the point of leaving Burtonport station on her long way to Derry on the 24th June, 1937. H C Casserley **Above left:** Very close to the same point today. **Top right:** A few moments earlier no. 12 was shunting various carriages and vans to make up her train. This is one of the few early views of Burtonport Station. **Above right:** Though partly derelict, the station buildings and platform are still standing.

So there we are in Burtonport. But where do we go from here? Well, you might like to drop in on Dungloe, or visit Ardara or Glenties, or how about exploring another Donegal narrow-gauge railway and trying a tour from our first guide which covers the lines out to Killybegs, Ballyshannon and through the Barnesmore Gap?

But if it's just back home to Letterkenny that you want well all you need to do is get back onto the N56 and follow the car in front all the way round northern Donegal to the shores of Lough Swilly itself. Of course, you'll get some wonderful scenery and pass through some great places and, who knows, you might be tempted to take a wee detour around some of the hundreds of miles of the Atlantic coast drive, or visit one of the many golden beaches, or spend a night at a great hotel or comfortable B&B.

But above all, take your time and savour your visit to Ireland's most northern and, we would say, most beautiful county.

Whatever way you do it, make sure you enjoy it.

We did!

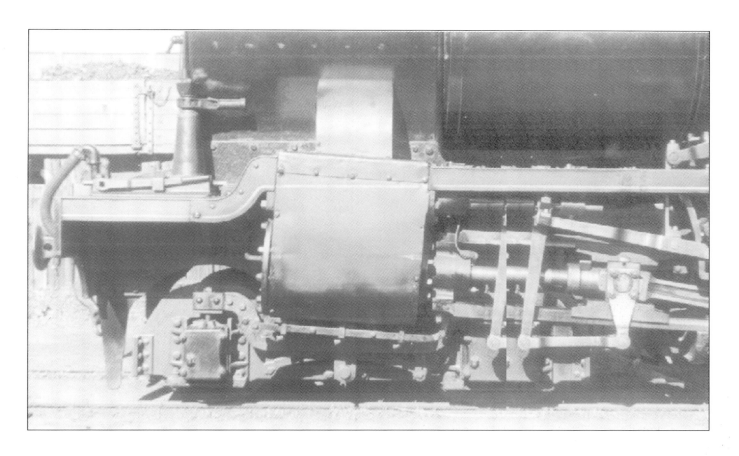

THE LOCOMOTIVES AND ROLLING STOCK OF THE LONDONDERRY AND LOUGH SWILLY RAILWAY

We could not conclude this brief review without giving the Lough Swilly locomotives and rolling stock a mention.

Over the years the Swilly owned and operated some of the most powerful locomotives to be found on the Irish three-foot narrow-gauge. But, unfortunately, nothing remains today of these majestic locos or, practically, of the rolling stock.

Regrettably all the locomotives were scrapped when the line finally closed in 1953. At that time there were just no railway enthusiast groups pushing for preservation of the old lines.

Ah, if only the Swilly had managed to survive for another six years or so, then something might have been saved. It certainly would have benefitted from the awakening interest in steam preservation and the then new museum in Belfast, as was the case of the railway's sister further south – the County Donegal Railway. But if ifs were pounds we'd all be millionaires!

Steam locomotives were, and still are, identified by their wheel arrangement. Therefore a 4-6-0T loco would have four leading wheels (usually grouped on a pivoted unit or bogie), six coupled driving wheels driven by the pistons, and two trailing wheels carried on another bogie. The letter T indicates a tank engine, one with water tanks along both sides of the boiler and coal in a small bunker at the back of the cab. They wouldn't have had a tender.

All but two of the Swilly's locos were tank engines.

The exceptions were nos. 11 and 12. They had the distinction of being the only tender engines *ever* to run on an Irish narrow-gauge line and also the first engines in Ireland to have eight coupled wheels.

They weighed 37 tons but, because of the eight driving wheels, the weight was well spread giving an axle loading of only 6 tons 12 cwt.

No. 12, if given the opportunity, would have been a prime candidate for preservation as she outlasted no.

11 which was used for spares to keep her sister loco operational.

As mentioned earlier, the first section of track laid by the Lough Swilly railway in 1863 was, of course, to the Irish standard gauge of five feet three inches. The Letterkenny Railway was built to the three foot gauge and this led to the eventual re-gauging of the entire system to this gauge. By 1885 the Swilly had, for the first time, a unified narrow-gauge system stretching some 31 route miles.

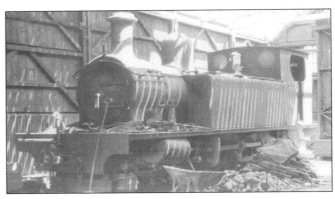

All six of the original locomotives used on the old five foot three inch system were 0-6-0 tank engines. After the regauging these were no longer of any use and they were either scrapped or sold to the Cork, Bandon and South Coast Railway at the other end of Ireland. No 4 *St Patrick* and no. 5 *St Columb* were sold to the CB&SCR.

The Swilly then bought three-foot gauge replacement locomotives. The first engine, named *J T Mackey*, was a 0-6-2 tank engine and arrived in 1882. This was soon followed by no. 2 *Londonderry* and no. 3 *Donegal*. No. 4 *Inishowen*, an 0-6-0 tank loco arrived in 1885.

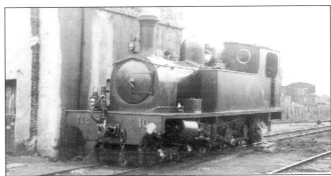

Between 1885 and 1912 the Swilly purchased two 2-4-0 locomotives, eight 4-6-2 tank engines, four 4-6-0 tanks and two 4-8-4 tank locos and, last, the two 4-8-0 tender engines.

The most noteable members of the fleet were these two tender engines, nos 11 and 12, mentioned earlier, and nos. 5 and 6, the last two to be actually built, in 1912. Nos 5 and 6 were magnificent giant 4-8-4T locomotives and were the only steam engines with this wheel arrangement to work in these islands.

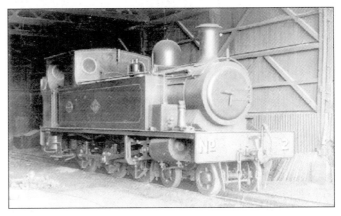

Again the Swilly was unique in being the only Irish railway company to use engines with the 4-6-2T wheel arrangement on their locos and they proved to be very popular with their crews.

Lough Swilly locomotives were identified by their numbers which were often painted on their buffer beams. However, contrary to popular opinion, some engines (seven in all) did bear name plates. Four engines did have their names removed over a period of time but three managed to retain them throughout their working lives. These were, appropriately, no. 1 *J T Mackey*, no. 2 *Londonderry*, and no. 3 *Donegal*.

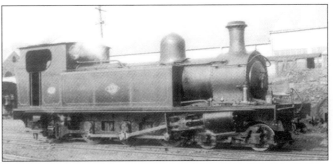

No. 4 *Inishowen* received her name in 1885 and kept it until 1914. No. 7 was initially unamed when built in 1901 but was repainted and named *Edward VII* in 1903 as she was chosen to work the royal train between Buncrana and Derry when Edward VII (the king, that is) and Queen Alexandra visited Derry in July of that year.

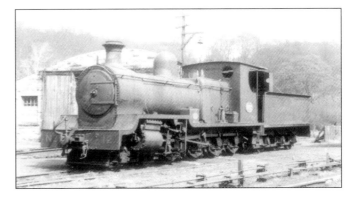

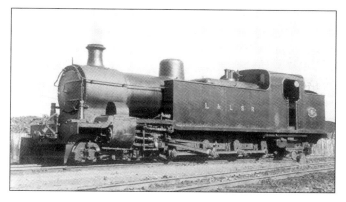

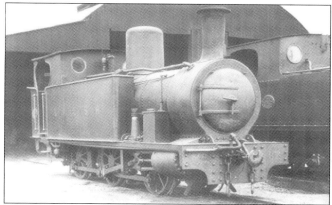

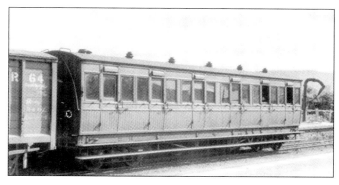

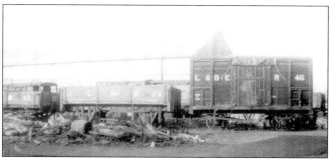

Left, top to bottom: **1** – Loco no. 7 at Pennyburn shed, 1937. **2** – No. 10 takes on water, 1948. **3** – No. 2 on shed in 1948. **4** – One of the last in service, no. 15 in 1953. **5** – The tender loco, no. 12, at Letterkenny, 20th April, 1953.
Above, top to bottom: **1** – The gentle giant, 4-8-4 no. 5 at Pennyburn platform on the 6th August, 1930. **2** – No 4/17 *Innishowen* on the same day. **3** – Coach no 11 built for the Extension Railway (note lettering). 1937. **4** – L&BER van no 46 and a couple of L&LSR wagons, Pennyburn, 1948. *All photos H C Casserley.* Of all the fine Lough Swilly engines not one survived into preservation, all fell to the cutter's torch.

The other two locomotives to have name plates for a limited time were two 4-6-2Ts, no. 9 *Aberfoyle* and no. 10 *Richmond.*

Locomotives used on the Letterkenny and Burtonport Extension Railway were lettered L&BER and numbered in a separate series. So, from 1902, the numbering system for the Burtonport locos started again at no. 1. The Board of Works insisted on separate numbering as they were responsible for all of the extension railway's rolling stock. even though the Swilly was itself responsible for the day-to-day running of the line.

In latter days the average cost of building a locomotive was about £2,500. Hudswell Clarke & Co built most of the locos, being responsible for nos. 5, 6, 7, 8, 11, 12, 15 and 16. Barclay and Co. built nos 1, 2, 3 and 4, while Kerr Stuart & Co were responsible for nos 9 and 10, Hawthorn Leslie & Co. for nos. 13 and 14, Stephenson & Co for nos 5A and 6A, and Black Hawthorn & Co. for the original nos. 1, 2, 3 and 4. In addition, some locos bore the maker's name plate and, later, also the distinctive Swilly logo: a diamond shape containing the ornate lettering LSR. The Burtonport stock bore simple L&BER lettering.

The livery was predominantly bright green with red buffer beams on which the number was painted in yellow. However, between 1914 and 1918 and again in the mid-1930s, the locos were painted black and lined in a variety of colours. Nothing is known of the livery of the original five-foot three-inch gauge locomotives.

The Swilly owned a total of 28 locomotives, including the six standard-gauge engines. They remained in service for an average of 36 years. One, no. 8, managed to survive 53 years of service.

Carriages, vans and wagons

Some of the locomotives on the Swilly may have been the most impressive and powerful of their time but the same was not true of the passenger coaching stock.

The carriages were rather shabby, invariably in need of repair, a good coat of paint and general tidy up. Some of the earliest six-wheel coaches remained in service right through to the line's closure and were really showing their age. Seating was rarely comfortable as most of them were of the wooden slatted type.

The Swilly neglected to provide other simple creature comforts, such as heating – steam heating was never installed. Passengers could get very cold indeed, especially in winter when they had to resort to the basic remedy of stomping their feet to keep warm. A small quantity of foot warmers were supplied to passengers from time to time and even these came second-hand from the Midland Great Western Railway.

A further 29 were eventually bought from the County Donegal Railway.

Carriages were initially lit by oil lamps and, later, by aceteylene gas burners mounted through holes in the roof. Gas lighting generators were housed in a metal box on one end of the carriage, it eventually wore out and was finally replaced by electric lights powered from batteries. These came from the Swilly's growing fleet of road buses.

Not a lot can be said about the rolling stock of the early standard gauge days from 1862 to 1884. There are no drawings or information on their livery as far as we can locate. The lack of documentation is probably due to the fact that the rolling stock was hired by the Swilly from the local businessman John Cooke and, later, by the contractor McCormick who was responsible for ballasting the track.

These individuals came to the aid of the Swilly as the company was not then in a position to pay for the rolling stock it had ordered.

As a standard-gauge railway the Swilly was first supplied by Fossick and Hackworth with two first/second composites, two third class carriages, one goods brake van, four flat wagons and four covered vans. As with the standard gauge locomotives these vehicles were sold to the Cork, Bandon and South Coast Railway after the 1885 regauging to the three-foot track.

The L&LSR had a large selection of rolling stock in the narrow-gauge days of 1885 to 1954. At one point, in 1930, the company possessed a total of 317 assorted vans, wagons and carriages. Keeping track (no pun intended) of the stock in use is also a difficult task as that used on the Burtonport extension was numbered separately and at one time no less than six separate series of numbering existed. And then vehicles would be damaged and recycled – born again in a different guise.

Some passenger bogie coaches, for example, were taken into the Pennyburn workshops and rebuilt as goods vans, thus extending their useful working life – a practice common on the neighbouring CDR system.

All Swilly coaches were wooden framed with timber planked sides and built on a metal chassis. The first carriages from Oldbury Carriage Co had six wheels, one axle set at each end and one in the middle. They were numbered no. 1 to no 22 and were built and supplied between 1884 and 1901. None of these vehicles had any luggage or brake compartments. They were all divided into five separate passenger compartments.

Coaches 23 to 35 were built in 1901 and ran on sets of bogie whels. They all had six passenger compartments apart from no. 24 which was a third class and had only five compartments.

Nos. 25, 32, 33, 34 and 35 were all third class brake coaches with only two passenger compartments. Coaches 28 to 35 were normally used on the Carndonagh line and were accordingly known by the railwaymen as the Carn coaches.

Carriages on the Burtonport extension line were numbered 1 to 13 and all ran on bogie wheel sets. Each bogie consisted of four wheels on two axles pivoted from a single point on the carriage underbody. These coaches had six passenger compartments, except for the four third class brake vehicles which had just three compartments. The Burtonport stock was owned by the Board of Works and they frequently complained to the Swilly about the use of their stock on other parts of the Swilly's system.

The Swilly owned a total of 110 flat wagons or timber flats as they were also known, built up with three- or four-plank sides. Twenty-six of these had centre doors. There were also 56 goods vans, some with parts of their roofs cut away and covered by canvas to facilitate loading by hand crane. Of the company's more unusual possessions mention should be made of a single horse box van, a mess and tool van, a stores van, a travelling crane, a stone engine and stone breaker. Plus, of course, that familiar sight on Donegal narrow-gauge lines: six oil tank wagons owned by BP.

A total of 35 flat wagons and 51 covered vans were on the stock list of the Burtonport line, the greater number of covered vehicles highlighting the importance of the fish trade on this line.

Carriages were painted in a variety of sombre colours over the years. At first they were adorned with dark brown above and light brown below followed, in 1902, by cream upper panels and dark red below. At some point they were painted entirely black but, finally they received a coat of light grey and that was the way in which they finished their working lives – and the life of the railway – in 1953.

Most people's abiding memory of the old Lough Swilly Railway is of a dirty black loco hauling a motley collection of light grey coaches, wagons and vans through the wild and wet hills and glens of Donegal.

Destination Donegal!

A whistle-stop tour of the various ways of getting to the home of the Lough Swilly Railway.

Travelling to County Donegal is all part of your holiday and we want you to enjoy every moment of it. There are a number of ways of getting to this wild and remote outpost of Europe and below we give some tips that you may find useful.

By air

County Donegal has its own airport at Carrickfinn, north of Dungloe, on the western coast. Flights from Glasgow serve this airport.

Further south there is Sligo airport which has regular connecting flights with Dublin and, therefore, all European cities, and services to the United States.

Even further south is Shannon airport with its regular transatlantic services. To the east there is the City of Derry Airport with services to Glasgow; Belfast International (Aldergrove) with hourly flights from London and regular services from several other British cities and with flights from the rest of Europe; and Belfast City Airport with services from Britain and a growing list of direct connections with Europe.

Car hire can be arranged either with your airline operator (Aer Lingus, for example, provide several fly-drive packages) or when you arrive at Dublin, Shannon or Belfast. Shannon airport is 282km from Donegal.

By sea

Car ferry services operate between Cairnryan to Larne (north-east of Belfast) and Stranraer to Belfast, and by high-speed Seacat hydrofoil; to Dun Laoghaire (south-east of Dublin) from Holyhead; to Rosslare (in Co. Wexford, on the south-eastern corner of Ireland) from Fishguard, Pembroke, Le Havre and Cherbourg; and to Cork (Ringaskiddy) from Swansea, Roscoff and Le Havre.

Getting there

Once you're on Irish soil then it's fairly straightforward travelling to Donegal.

From **Larne** (190km) take the A8 signposted for Belfast and, just after Ballynure, look for the signs for the M2 motorway. Take the motorway and stay on it until it's end just west of Randalstown and then follow the A6 all the way to Derry. Cross the River Foyle in Derry via the new road bridge and follow the signs for Letterkenny.

After crossing the border at Bridgend (Welcome to Donegal!) take the N13 to Letterkenny.

From **Belfast International** (Aldergrove), (170km) by hire car, follow the exit route to the main road junction and look for the A26 towards Antrim. Travel through Antrim and follow the signs to the M2. Then follow the route as above.

From **Belfast City Airport** by hire car, simply follow the signs directing you towards the M2. At Bridgend make sure you take the new motorway bridge. By the way, as you cross the River Lagan you'll see the new railway bridge on the left reuniting the old GNR(I), BCDR and Belfast Central Railway with the once isolated section of NIR running from York Road to Larne.

From **Dun Laoghaire** (225km) follow the signs for the M50 and Lucan and look out for the turning onto the N4. If you miss it, turn back and try again because this is the road that is going to take you right across Ireland. Once on the N4 take it through Maynooth, Mullingar, Longford and Boyle on into Sligo. Here you want the N15 signposted for Donegal and Derry. Sweep northwards with Benbulben Mountain to your right and, just south of Bundoran, you enter Co. Donegal. Just stay on this road for Donegal Town and Letterkenny.

From **Dublin Airport** (200km) by hire car, from the exit follow the signs for Blanchardstown and the M50 to the west of the city. Once on the M50 look for and take the junction for the N4 and follow the route as above.

From **Rosslare** (389km) it's quite a run! Follow the signs to Wexford. This will, eventually, get you on to the N25. Just west of Wexford look for the N80 signposted for Enniscorthy. Follow this road through Enniscorthy, Bunclody, Carlow, Stradbally, Portlaoise, Tullamore and Clara to its junction with the N6 at Moate. Take the N6 westwards to Athlone then look for the N61. Take this and follow it through Roscommon, Tulsk and Boyle where it joins the N4. Follow this through to Sligo and then it's as above. Donegal is just over the mountains and the Atlantic is to your left.

From **Cork** (Ringaskiddy) (408km) follow the signs to the city centre which you'll just have to navigate through. You're looking for the N20 signposted for Mallow and all points north. In Cork city there is an extensive one-way system so if you need to stop and ask then you're looking for John Street Upper and Watercourse Road (the first leads into the second, and both are the N20). Once successfully on the N20 take

it through Mallow, Ráth Luirc, Croom and into Limerick. Another city centre to negotiate! Look out for the signs to Ennis and Shannon Airport. These will take you onto the N18 which you follow right through Ennis and Gort practically into Galway. Before the city though, at Oranmore, take the N64 which leads to Claregalway and the N17. Now stay on this road through Tuam, Claremorris, Charlestown, Tubbercurry and on into Sligo. Then head for the northern mountains as above. Donegal, at last!

From **Shannon Airport** (282km), by hire car, its easy! Take the exit road to Hurlers Cross where you can join the N18 and then follow the route as above.

By train and coach

Via Larne you can travel to Derry by Northern Ireland Railways and then take the scheduled Bus Éireann or Lough Swilly services to Letterkenny.

Via Belfast International Airport take the Airbus to the Europa Bus Station for Ulsterbus coaches to Donegal via Derry; or stay on the Airbus to Central Station and take the NIR service to Derry and then by bus as above.

Via Dun Laoghaire the excellent DART (Dublin Area Rapid Transit) electric train will take you to Dublin city centre and you can then pick up the bus link from the Central Bus Station (Busaras) in Store Street to Heuston Station. The train can take you to Sligo and there you can join the Bus Éireann Derry service in the station forecourt. This travels up the main road northwards to Letterkenny. Alternatively, you can travel by an express Bus Éireann service (from the quayside) or one of several independent operators (from O'Connell Street) direct to Donegal.

Via Dublin Airport, again take the Airbus to the Central Bus Station and proceed as above.

Via Rosslare your best bet is to travel to Dublin by train or coach and follow the details above. If you want to really experience Ianród Éireann, though, check the times beforehand and catch the daily train towards Limerick via Limerick Junction (a classic railway junction for enthusiasts with its rail-rail level crossing) and then transfer to the Cork-Galway coach, then on to Co. Donegal via the Derry coach.

Via Cork you can either travel north-east to Dublin by train or coach and then as above or take the Cork to Galway Bus Éireann express service and change at Galway bus and train station for the Derry express service, as above.

Via Shannon Airport, there are airport bus connections with the Cork-Galway express coach service at Limerick as well as at least one Galway service (and

on to Letterkenny via the Derry service) which calls in at Shannon.

There are many special travel deals available and you should check with your travel agent for the best value and convenience. It's well worth investing in a Bus Éireann 7 or 14 day travel ticket. These are reasonably priced and can cover all your travelling in Ireland, including your initial travelling to Donegal. They vary in extent: bus and coach; bus, coach and rail; Irish Republic only; Irish Republic and Northern Ireland.

It's our experience that if you first find out the cost of your travelling from your point of arrival in Ireland to Donegal, and then use the first day of your travelcard to cover this, and your final return journey, then it really helps to keep costs down. These tickets must be obtained from Bus Éireann via your travel agent *before* entering Ireland.

Finally, with regard to buses, coaches and trains, it is essential that you get timetable information before you book. Make sure you buy the Bus Éireann timetable booklet, usually published during May of each year. Special summer-only services operate from about the end of May to early September so it's important to check up. The drivers, guards and other staff of Bus Éireann, Iarnód Éireann, Ulsterbus, Belfast Citybus and NIR are very helpful and patient so don't be afraid to ask. Also Bord Fáilte and the Northern Ireland Tourist Board offices are always well worth a visit for advice, assistance (including accomodation booking) and further information.

Being there

Of course, in giving you this overall guide of how to reach Donegal we've completely ignored all the wonderful landscape you'll be travelling through and not mentioned a single one of the excellent hotels, bars, restaurants and guest houses that lie on your route. We haven't given approximate travelling times because everyone likes to set their own pace and there's plenty to see and enjoy on the way to Donegal.

We've tried to give you the most straightforward routes but if you see some sun-speckled mountains off to your left, or a quiet green glen to your right, or even one of the many tempting bars then our advice is: stop! Get out and enjoy yourself.

Relax, you're in Ireland, where time passes, but never flies.

The Londonderry and Lough Swilly Railway
Bus Timetable

We're providing details of the Swilly's modern bus services around County Donegal to give readers the opportunity to plan out journeys to rediscover the old railways by using public transport. Please note, that these details are given for guidance only and should not be relied on. For the latest information, including details of summer only services, please phone the company direct. A list of phone numbers is given on the next page. A good tip is to make use of the 8-days unlimited travel tickets available for use on any of the company's scheduled services and obtainable at bus depots.

Derry – Buncrana (Graving Dock to Buncrana *via* Bridgend)

Monday – Friday

		A								
Derry	0745	0850	1100	1215	1315	1415	1515	1615	1715	1805
Bridgend	0800	0905	1115	1230	1330	1430	1530	1630	1730	1820
Burnfoot	0803	0908	1118	1233	1333	1433	1533	1633	1733	1823
Fahan	0812	0917	1127	1242	1342	1442	1542	1642	1742	1832
Buncrana	0825	0925	1135	1250	1350	1450	1550	1650	1750	1840

Saturdays

Derry	0800	0905	1015	1115	1215	1315	1415	1515	1615	1715	1805	1930
Bridgend	0815	0920	1030	1130	1230	1330	1430	1530	1630	1730	1820	1945
Burnfoot	0818	0923	1033	1133	1233	1333	1433	1533	1633	1733	1823	1948
Fahan	0827	0932	1042	1142	1242	1342	1442	1542	1642	1742	1832	1957
Buncrana	0835	0940	1050	1150	1250	1350	1450	1550	1650	1750	1840	2005

Sundays

Derry	1430	1800	1945	2200
Bridgend	1445	1815	1957	2212
Burnfoot	1448	1818	2003	2218
Fahan	1457	1827	2012	2227
Buncrana	1505	1835	2020	2235

A = change at Bridgend

Buncrana – Derry

Monday – Friday

Buncrana	0800	0905	1100	1215	1315	1415	1515	1715	1800
Fahan	0810	0915	1110	1225	1325	1425	1525	1725	1810
Burnfoot	0817	0922	1117	1232	1332	1432	1532	1732	1814
Bridgend	0820	0925	1120	1235	1335	1435	1535	1735	1820
Derry	0835	0940	1135	1250	1350	1450	1550	1750	1835

Saturdays

									B				
Buncrana	0800	0905	1015	1100	1215	1315	1415	1515	1615	1715	1810	1915	2030
Fahan	0810	0915	1025	1110	1225	1325	1425	1525	1625	1725	1820	1925	2040
Burnfoot	0817	0922	1032	1117	1232	1332	1432	1532	1632	1732	1852	1932	2047
Bridgend	0820	0925	1035	1120	1235	1335	1435	1535	1635	1735	1855	1935	2050
Derry	0835	0940	1050	1135	1250	1350	1450	1550	1650	1750	1910	1950	2105

Sundays

Buncrana	1600	1900	2100	2300
Fahan	1610	1910	2110	2310
Burnfoot	1617	1917	2117	2317
Bridgend	1620	1920	2120	2320
Derry	1635	1935	2135	2335

B = via Inch Island

Buncrana – Carndonagh (The Carn Line)

Monday – Friday

		M–T	FO	M–T	FO
Buncrana	0840	1300	1345	1745	1815
Drumfries	0855	1315	1400	1800	1830
Clonmany	0910	1330	1415	1815	1845
Ballyliffin	0915	1335	1420	1820	1850
Carndonagh	0930	1350	1435	1835	1905

M–T = Mondays to Thursdays
FO = Fridays only

Saturday

Buncrana	1215	1415	1815
Drumfries	1230	1430	1830
Clonmany	1245	1445	1845
Ballyliffin	1250	1450	1850
Carndonagh	1305	1505	1905

Carndonagh – Buncrana

Monday – Friday

Carndonagh	0725	1000	1600
Ballyliffin	0740	1015	1615
Clonmany	0745	1020	1620
Drumfries	0800	1035	1635
Buncrana	0820	1050	1650

Saturdays

Carndonagh	1000	1315	1700
Ballyliffin	1015	1330	1715
Clonmany	1020	1335	1720
Drumfries	1035	1350	1735
Buncrana	1050	1405	1750

Derry – Letterkenny (The Letterkenny Railway)

Monday – Friday

					D		
Derry	0730	0850	1230	1615	1620	1700	1810
Bridgend	0745	0905		1630			
Newtown	0800	0920	1255	1645	1645	1725	1835
Manor	0810	0930	1305	1655	1655	1735	1845
Letterkenny	0830	0950	1325	1715	1715	1755	1905

Saturdays

				D		E		F		
Derry	0900	1030	1220	1230	1330	1500	1700	1700	1810	
Bridgend		1045	1235		1345	1515		1715		
Newtown	0925	1100	1255	1255	1400	1530	1725	1730	1835	
Manor	0935	1110	1305	1305		1540	1735	1740	1845	
Letterkenny	0955	1130	1325	1325		1600	1755	1800	1905	

D = change at Newtown, E = via Carrowan, F = via Carrowan on request

Letterkenny – Derry

Monday – Friday

Letterkenny	0745	0835	1000	1330	1615	1815
Manor	0805	0855	1020	1350	1635	1835
Newtown	0815	0905	1030	1400	1645	1845
Bridgend		0925			1700	1900
Derry	0840	0940	1055	1425	1715	1915

Saturdays

		H		I					
Letterkenny	0745	0910	1000		1330		1500	1615	1815
Manor	0805	0930	1020		1350		1520	1635	1835
Newtown	0815	0940	1030	1300	1400	1400	1530	1645	1845
Bridgend		1000		1315		1415		1700	1900
Derry	0840	1015	1055	1330	1425	1430	1455	1715	1915

H = via Carrowan, I = change at Newtown for Bridgend-Buncrana

Letterkenny – Falcarragh – Dungloe

(The Letterkenny and Burtonport Extension Railway)
Monday – Saturday

	J	K		L	M
Letterkenny	1005	1325	1615		1805
Kilmacrennan	1030	1330	1635		1830
Creeslough	1045	1410	1650		1845
Dunfanaghy	1100	1425	1715	1715	1910
Falcarragh (a)	1115	1440		1730	1925
Falcarragh (d)	1200	1440		1730	1925
Knockfola	1240				2010
Gweedore			1505	1755	
Crolly	1315	1525		1815	2045
Kincasslagh	1335			1835	
Burtonport	1350			1850	
Dungloe	1400	1545		1900	2105

J = change at Falcarragh, K = Monday - Friday, L = not Tuesdays or Saturdays,
M = change at Letterkenny and Dunfanaghy

Dungloe – Falcarragh – Letterkenny

Monday – Saturday

	N	SO	O	N	N		
Dungloe			0900	0930	1600	1605	
Burtonport			0910			1620	
Kincasslagh			0920			1630	
Crolly			0945	0945	1615	1705	
Gweedore				1010	1635		
Knockfola			1015			1735	
Falcarragh (a)			1100	1035	1700	1815	
Falcarragh (d)			1200	1035	1700	1840	
Dunfanaghy	0730	0730	1220	1055	1715	1715	1900
Creeslough	0745	0745	1240	1110	1725	1725	
Kilmacrennan	0800	0800	1255	1125	1750	1750	
Letterkenny	0820	0820	1320	1145	1810	1810	

N = Mondays - Fridays only, SO = Saturdays only, O = change at Falcarragh and
Letterkenny

Further details can be obtained by phoning the Swilly bus depots:

Derry 262017
Buncrana 61340
Letterkenny 22863
Dungloe 21380

The Donegal Railway Heritage Centre

The Old Station House
Donegal Town, Co. Donegal, Ireland

Telling the story of the County Donegal Railway: museum, extensive photo display, continuous video showings, facsimile posters and publications, artefacts, sales shop – a unique celebration of the "Wee Donegal"!

Opening times:

June – September

Monday – Saturday: 10 am – 5.30 pm;

Sunday: 2 pm – 5 pm

January – May, October – December
Monday – Friday: 10 am – 4 pm
Closed Saturday and Sunday

Admission:
Adults: £1.00 (concessions: 50p)
Children (10 – 15): 50p; under 10: free

Unlimited re-admission on date of ticket issue.

County Donegal Railway Restoration Society

for details of membership and other publications, please write or phone 073-22655.

Top: May, 1995 saw the opening of the Donegal railway Heritage Centre by the CDRRS in the newly-restored Station House at Donegal Town. This museum and visitors' centre is the first of several restoration projects being undertaken by the society which also include rolling stock, a steam loco and, eventually, a rebuilt section of the original CDR route. *Above:* Pat "the Cope" Gallacher TD MEP and CDRRS chairman Jon Williams unveil the opening plaque as the band plays and the audience applaud! After over 20 years of dereliction Donegal Station is back in business. *Below:* The station site is being developed by the society and will house some of its growing collection of restored rolling stock. This photo is already out of date as the extension, this end of the main building, has been renovated, roofed and opened as part of the museum.

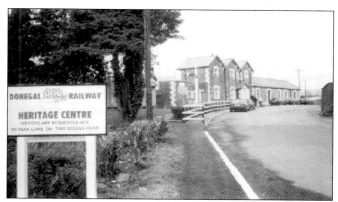

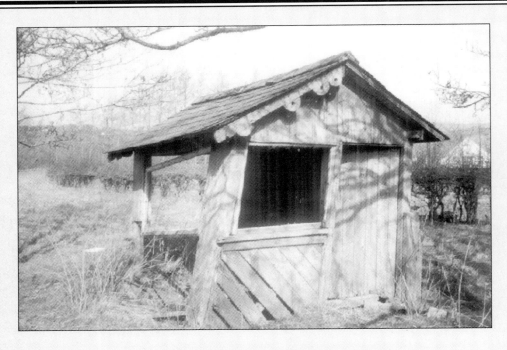

The Last Box!

As we were preparing this guide for publication we realised that the broken-down bothy on the old platform at Newtowncunningham Station was in fact the very last remaining L&LSR signal box. CDRRS secretary Dave Bell and projects manager Patrick Stewart promptly approached the present-day owners and they very kindly agreed to donate the signal box to the Society.

As we go to press this venerable structure is being dismantled on site and moved to the Society's Donegal Railway Heritage Centre. The timbers will be given preservation treatment and the box will be rebuilt and restored back to its original condition. It will then form part of the Society's growing group of external exhibits at the centre and, when we begin to relay a section of the old CDR track, the box will be returned to its original purpose – that of controlling the movement of trains along a narrow-gauge Donegal railway line.

Its very pleasant to prepare this guide and, through our research, be able to save for posterity a unique reminder of the Londonderry and Lough Swilly Railway.

The authors would like to express their thanks to Richard Casserley for his generosity and support in allowing us to reproduce many his father's and his own photographs free of charge so that as much income as possible from the sale of this guide can be devoted to the CDRRS's project of restoring a section of the old County Donegal Railway and operating vintage CDR steam trains.

Practically all of the historic photographs appearing here were taken by Richard or his father in the course of several visits to County Donegal over a number of years. We are indebted to their foresight and love of railways in saving for us many images of an era now, alas, long gone. Having seen their photographs in various books and magazines it has been a wonderful experience to follow in their footsteps, many years later, and discover just what reminders of Donegal's railway past do remain.

We would also like to thank our families for their patience and forebearance while being toured around some of the more muddy, windswept and thorny railway locations. We can honestly say that neither brambles, aggressive dogs nor sucking bogs kept us from our task!

But finally, and most importantly, we would like to thank all the people of Donegal who we met in our explorations and who made us so welcome and provided many anecdotes and reminscences about the past. Those long-off days when the steam train was the *only* way to travel any great distance and the familiar sound of its whistle and the rattle of its wheels were a part of everyday life in this county of wide ocean vistas, mountains stretching to the skies and white-painted cottages nestling in every glen.

Dave Bell, Letterkenny
Steve Flanders, Belfast